IMAGES
*of America*
PHOENIXVILLE

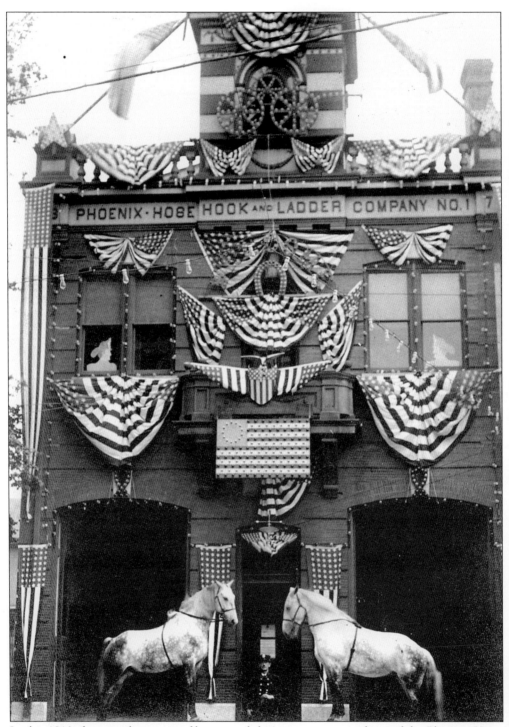

In this 1910 photograph, a team of horses and their trainer pose in front of the Phoenix Hose, Hook & Ladder Company No. 1 on Church Street. The engine house shown here was completed in 1901 and would retain much of its original structure until the present building was completed in the 1970s.

# Images of America
# Phoenixville

Vincent Martino Jr.

Copyright © 2002 by Vincent Martino Jr.
ISBN 0-7385-1112-9

First printed in 2002.
Reprinted in 2003.

Published by Arcadia Publishing,
an imprint of Tempus Publishing, Inc.
2A Cumberland Street
Charleston, SC 29401

Printed in Great Britain.

Library of Congress Catalog Card Number: 2002109307

For all general information contact Arcadia Publishing at:
Telephone 843-853-2070
Fax 843-853-0044
E-Mail sales@arcadiapublishing.com

For customer service and orders:
Toll-Free 1-888-313-2665

Visit us on the internet at http://www.arcadiapublishing.com

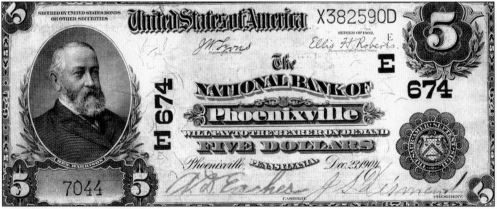

A 1902 $5 bill was printed as national currency by the United States. National notes were the precursor to the Federal Reserve notes of today but are still legal tender. This one was printed with "National Bank of Phoenixville" on it, along with a likeness of Benjamin Harrison. It also says, "Phoenixville, Pennsylvania" and bears the signatures of the bank's cashier and president. The National Bank of Phoenixville was located on Bridge Street to the Colonial Theater's left.

# CONTENTS

| | | |
|---|---|---|
| Introduction | | 7 |
| 1. | Humble Beginnings | 9 |
| 2. | Business and Industry | 27 |
| 3. | Growth and Prosperity | 61 |
| 4. | Living and Learning | 85 |
| 5. | Town and Country | 103 |
| 6. | The Sporting Life | 121 |
| Acknowledgments | | 128 |

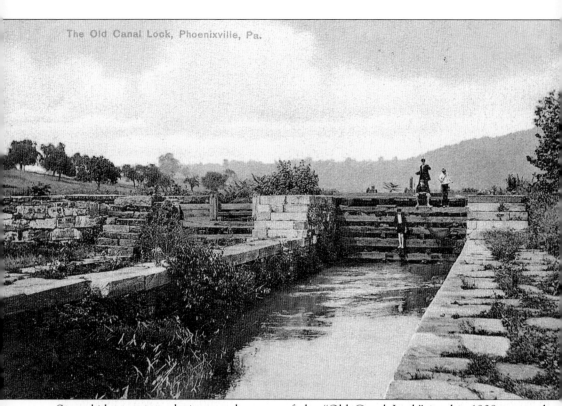

Some kids are seen playing on the steps of the "Old Canal Lock" in this 1908 postcard. Although it may be hard to imagine, this portion of the canal system was already obsolete by the early 20th century.

# INTRODUCTION

To follow Phoenixville's evolution throughout the last two centuries is to follow a meandering path through time and progress. Although our community may represent but a fragment of the nation's composition, Phoenixville epitomizes small-town America on many different levels. In its history, the town has seen great social, economic, industrial, and cultural strides. Since its inception, a commitment to religious and ethnic diversity has helped Phoenixville do its part in maintaining America's image as the "great melting pot." Phoenixville's origins can be traced directly to the original land grant entrusted to William Penn centuries ago. The first European settlers arrived at the village of Manavon in 1713. By the mid-18th century, James Starr had built a gristmill and some log homes in the immediate area. As the community started to grow, the thought of incorporating the village became the top priority to many people. On March 5, 1849, the borough of Phoenixville was born.

As the eastern seaboard became more populous with the virtual explosion of immigration in the late 19th and early 20th centuries, Phoenixville absorbed this new wave of immigrants into its fabric. As population increased, so too did the need for consumer goods and services. Making this possible was the advent of rail transport and travel. No longer would Phoenixville be a rural community relying on subsistence farming from its immediate area, but a viable town connected to the rest of the country by train. The Phoenix Iron Company had sprung to life from its infancy as a nail factory located along the Schuylkill River. With each passing year, the landscape of Phoenixville became dotted with commercial and industrial sites. Naturally, business sprouted up along the center of town—convenient to both the steel property and the rail stops. With this burgeoning existence came the necessity for vast living space. Residential areas began to take root in all corners of the town. From grand dwellings to row homes, there was something for everyone.

The town would grow continuously into the 20th century, aided in part by the stimulation in business provided by various war efforts and the lingering Industrial Revolution. As infrastructure was developed, Phoenixville became a vital part of Chester County and suburban Philadelphia. The town's prominent location along the Schuylkill River with its canal system, added great credence to this fact. Growth and prosperity continued into the 1960s, before shifts in the economy would begin to play a role in Phoenixville's history. This was the age when cars were available to a citizen of almost any means, and people were easily able to travel beyond the borders of the small town. It was also a time when malls had begun to pop up here in suburbia, and suddenly the small businesses located downtown began to feel the crunch. The

steel mill, a backbone of Phoenixville's economy and the community itself started to see that there may be difficult times ahead. All across America, storefronts were shuttered when their businesses could no longer remain competitive. Factories and industries seemed vacant almost overnight, as less expensive foreign goods became readily available. Racial tension and the quest for equal rights spilled over into our small town and began to distort a once rosy outlook attached to the community. By the 1980s, Phoenixville was feeling the pressure gripping much of America at that time. In only a few short years, the Phoenix Steel Corporation would succumb to the inevitable by stopping production entirely at the last operating facility. This cold, hard fact sounded a death knell in the community and suddenly the future seemed bleak. At this point, Phoenixville seemed to be teetering on the brink of disaster. Unemployment had increased, businesses had closed, and crime was on the rise; but the determined residents of Phoenixville would not let the town fall to a death common of so many other small towns across the country.

Many people in Phoenixville had their roots here and were steadfast in their resilience when it came to the town they so knew and loved. Others were new to the community, destined to raise a family perhaps, but to make a life for themselves here regardless. The common bonds between these two groups of people were love, hope, and admiration for the little town sitting on the Schuylkill River's edge. It soon became apparent that if Phoenixville was to survive, it needed to reclaim its position as a thriving, attractive community. New homes were built and businesses were being slowly lured back into the community. Phoenixville had a lot to offer, including the advantage of living in a town that boasted urban, rural, and suburban neighborhoods. Stores and businesses soon opened that could satisfy almost every consumer need and fill a lot of much-needed jobs in the process. The renaissance Phoenixville has experienced could be a model for small towns all across America. Although there is still a long way to go and much work to be done, Phoenixville has a clear vision set before it. It is now up to the people to preserve what exists from our history, maintain what we have in the present, and dream of what is to come in the future. The name Phoenixville has an appropriate derivative that might accurately relate our past and foretell of what is to come. The phoenix is a mythological bird that lived for 500 years, burned itself, and from its ashes another phoenix arose. In literature, the term has come to symbolize something beautiful and rare. Within the confines of this book is a collection of images we can all use to celebrate the uniqueness of Phoenixville. You will be looking through a window to the past and at a story only photographs can tell.

# *One*
# Humble Beginnings

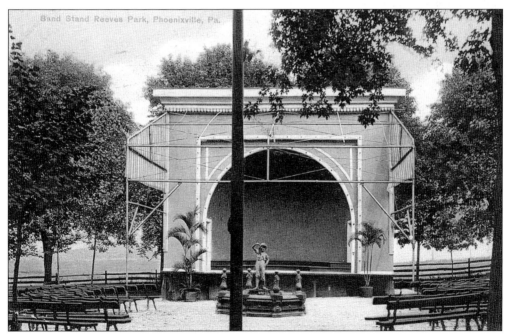

A 1909 postcard shows the bandstand in Reeves Park. Built at the turn of the century, it has played host to a variety of acts over the last 100 years. With the exception of the potted palms and statue at its front, the bandstand appears much the same today as it did then. Unfortunately, the ornate statue has since gone unaccounted for.

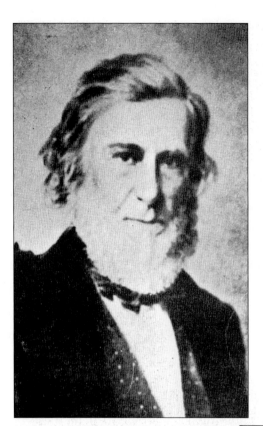

This early photograph shows David Reeves, a 19th-century industrialist responsible for the development of the Phoenix Iron Company. He was president of the firm from 1855 until his death in 1871.

This 1905 postcard shows the statue of David Reeves in Reeves Park. The statue was built to honor the president of the Phoenix Iron Company and was paid for by employees of that firm. The statue still stands in the same location near the entrance of the park, as it did in 1905.

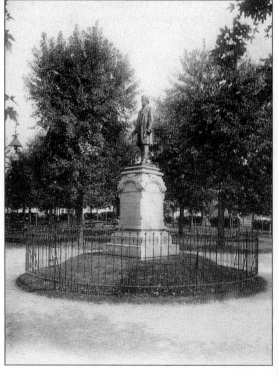

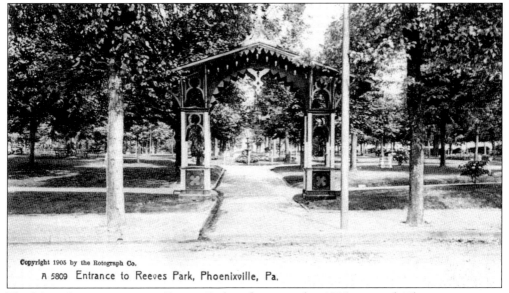

The Main Street entrance to Reeves Park is shown in this 1905 postcard. This entryway was made of wood and has long since been removed. It has been replaced by a metal entryway that leads visitors into the park from Main Street.

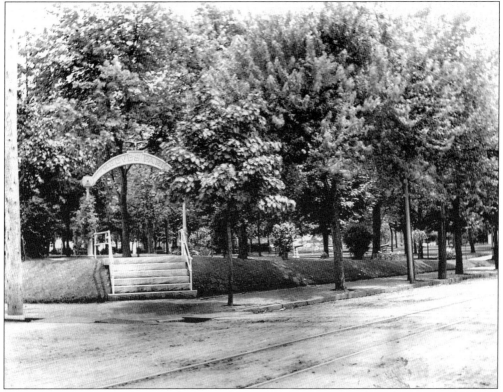

An early-20th-century photograph shows the entrance to Reeves Park at the corner of Second Avenue and Main Street. Although you can still enter the park at this spot, the entryway was removed long ago.

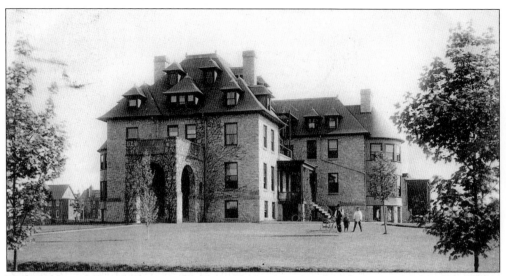

This photograph shows Phoenixville Hospital as it was in 1906. The original hospital had been located along Mill Street until this location near the site of the present-day hospital was found. Situated along Nutt Road, this building and subsequent additions stood until the current building was completed in 1968.

The two men in this photograph are Dr. Willis Smith (left) and Dr. Charles Doran. They are standing outside of the old Phoenixville Hospital, originally located on the same grounds as the present-day facility.

This is a 1910 view of the one-room schoolhouse located on the property of the Phoenix Iron Company. The structure was torn down many years ago, but the adjacent building remains on East Bridge Street to this day. The schoolhouse was located next to the company's main office building in Phoenixville.

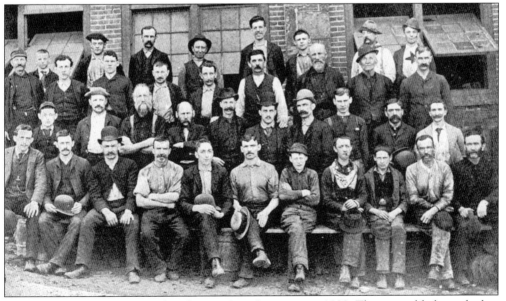

These are some employees of the Phoenix Iron Company in 1882. They most likely worked in the foundry building along North Main Street, which is visible behind them.

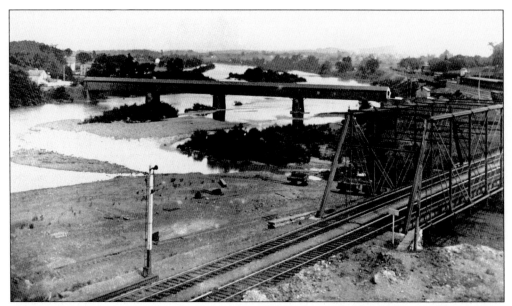

The covered bridge in this photograph once spanned the Schuylkill River between Phoenixville and Mont Clare. It was one of the longest covered bridges in regional history. It was destroyed by fire in 1912, after which a modern bridge would be built. (Keinard Collection, courtesy of Glenn C. Gagle.)

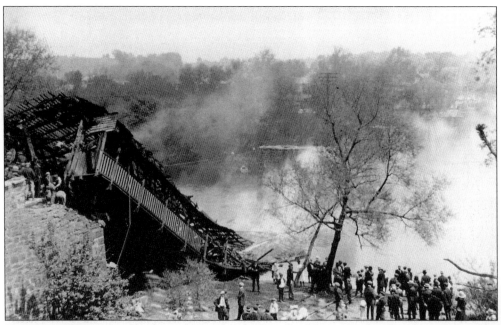

The Mont Clare covered bridge is shown shortly after the devastating fire that destroyed it. The remains of the bridge are shown smoldering and hanging on the Phoenixville side of the river. (Keinard Collection, courtesy of Glenn C. Gagle.)

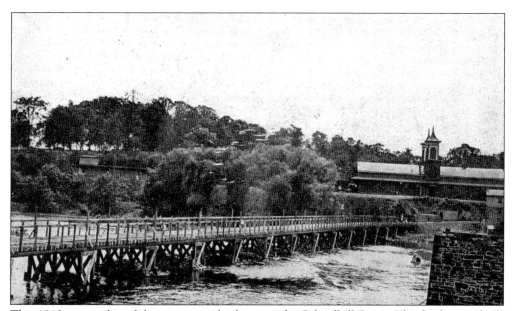

This 1913 postcard is of the temporary bridge over the Schuylkill River. This bridge was built to accommodate travelers going between Phoenixville and Mont Clare. The bridge existed while the new one could be built. The Philadelphia & Reading passenger station is visible in the background.

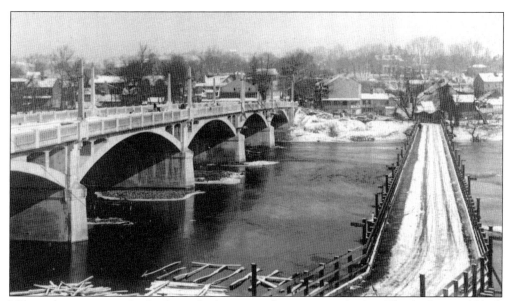

Here is the permanent bridge being built next to the temporary bridge. This bridge would link Montgomery and Chester Counties for many years before a new bridge would be built in 1997. (Keinard Collection, courtesy of Glenn C. Gagle.)

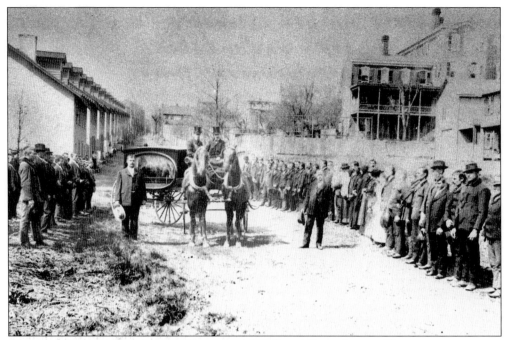

A funeral procession passes near the corner of Hall and Dean Streets. The approximate area shown is now a backyard to a private residence facing Starr Street. The homes in the background and to the left are still standing today. (Courtesy of Larry Swartz.)

The Neiman Funeral Home was located on First Avenue between Gay and Main Streets. To this day, the building has retained much of its original structure and is now home to the Forge Theater Company. (Courtesy of Larry Swartz.)

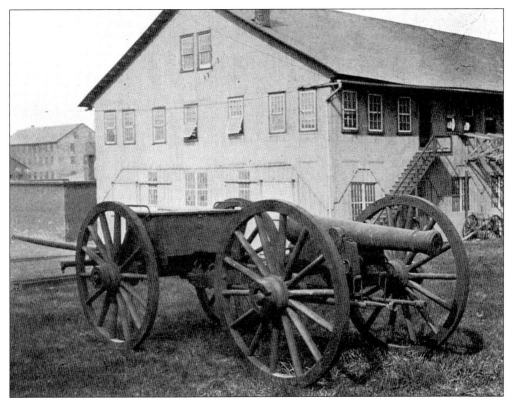

The famous Griffen gun was invented in the 1850s by John Griffen. Eventually, 1,400 of these 620-pound guns would be delivered to the Union effort during the Civil War. This gun is shown sitting on the Phoenix Iron Company's lawn at East Bridge Street in 1907.

This is the Benjamin Hardware Company in 1909. The building is located on Bridge Street, and its left side is now painted with the Phoenixville mural. Although the porch was removed long ago, the top of the building and its facade look much the same today.

Built in 1794, the Mennonite Society Church and Meetinghouse was located at the southwest corner of Main and Church Streets. The building was replaced in the early 1900s with the Central Lutheran Church, which still sits on the property today.

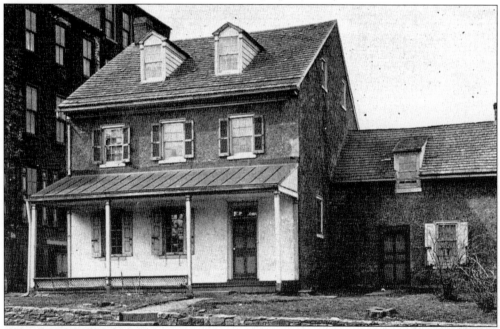

This 1910 photograph shows one of Phoenixville's oldest houses. Alterations obscure the original log cabin built in 1732 by James Starr, founder of the nail factory that would later evolve into the Phoenix Iron Company. The home is still there today, located on North Main Street at Taylor Alley.

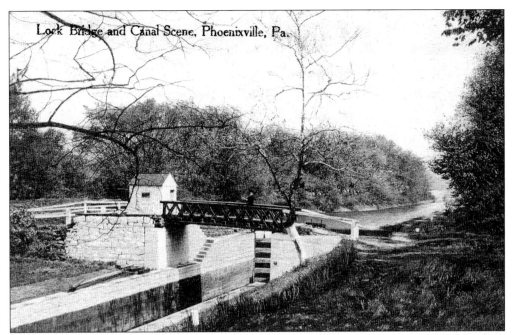

The lock bridge and canal are shown in this 1911 postcard. Located just over the Schuylkill River, the canal and the locks played an important role in keeping commercial and industrial vessels moving to and from Phoenixville. Ruins of the locks still line the canal, although the structure was torn down long ago.

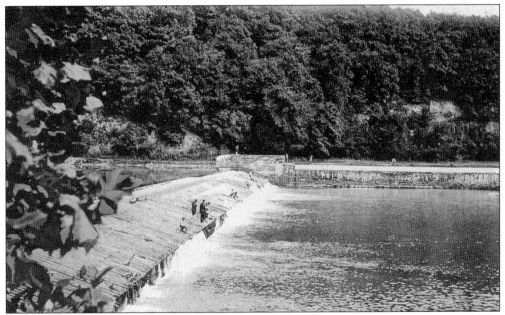

A 1909 postcard shows a view of the Black Rock Dam on the north side of Phoenixville. The dam was originally made of wood before being replaced by more practical concrete. Adults and children are playing on the dam in this image, including a child on what appears to be a tricycle.

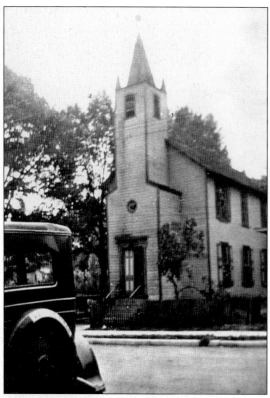

The Hungarian church, pictured in 1933, was located on Third Avenue at Buttonwood Street. The church was later moved to a new location on Main Street at Third Avenue. The wood exterior has given way to a stucco facade over the years, and the steeple has been removed. The original structure still stands today and is home to a private residence and barbershop. (Courtesy of Larry Swartz.)

This is a 1940 photograph of what was the Hungarian church, located on Third Avenue at Buttonwood Street. In this view, the front of the church has been transformed into a small store. The storefront is now home to Larry's Barber Shop. (Courtesy of Larry Swartz.)

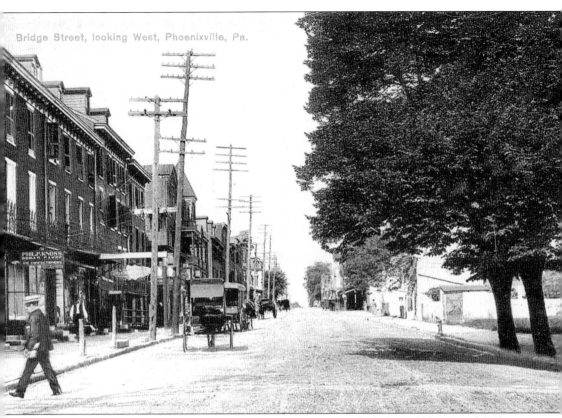

East Bridge Street is seen in this 1909 postcard. The buildings at the left would be part of Bridge Street until the late 20th century, when they had to be torn down. In the distance on the left side, the Columbia Hotel's elaborate wooden front porch is visible.

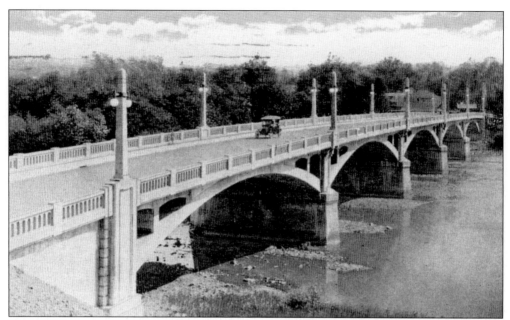

This 1916 postcard proudly displays the Intercounty Bridge spanning the Schuylkill River between Montgomery and Chester Counties. The bridge was built to replace a covered bridge destroyed by fire. This bridge would go on to serve travelers for decades before requiring demolition and replacement. It was blown up in the late 1990s by demolition experts in order to make way for construction of a new bridge.

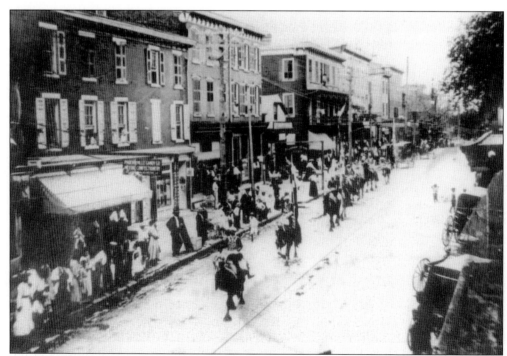

A 1911 parade in front of the 200 block of Bridge Street heads east toward Main Street. The sign at the left advertises the Phoenixville Candy Company, located at 208-210 Bridge Street.

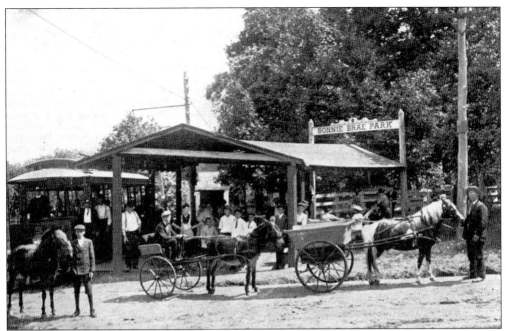

A 1907 photograph of Bonnie Brae Park is shown, with adults and children alike enjoying what was an early-20th-century amusement park, located on the outskirts of town. A trolley would carry people from Phoenixville to Bonnie Brae. The park is long gone, but the location's name is still the same.

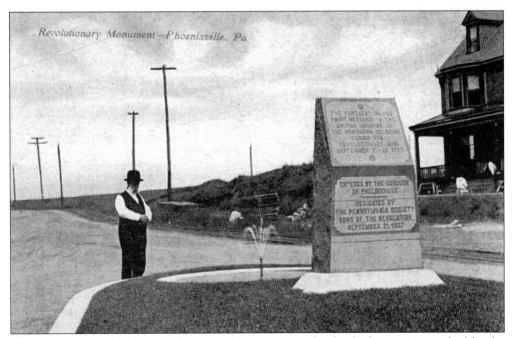

This 1907 postcard of the Revolutionary Monument marks the farthest point reached by the British during the invasion of the northern colonies. The monument is still located in the same spot at the intersection of Bridge Street and Nutt Road. The home at the right is also still there.

This 1908 view of South Main Street, taken from Second Avenue, shows Reeves Park at the left. In the distance, St. Ann's Catholic Church is on the right.

A 1921 postcard of Nutt Road shows "Nutts Avenue," as it was known then. In this image, an old car drifts lazily down the street where traffic is now almost omnipresent. The homes to the left are still there. Few modifications have been made to the structures externally, although some of the grand residences have been converted into multifamily dwellings.

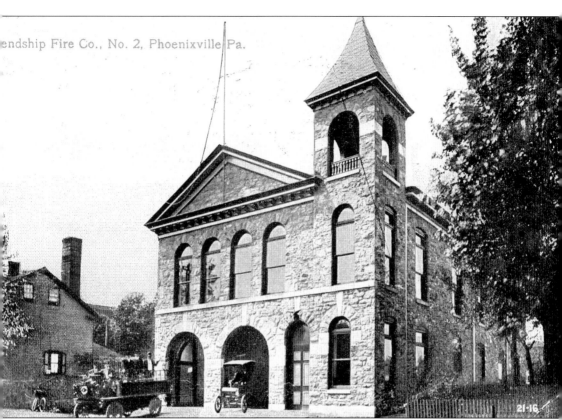

A 1912 postcard of the Friendship Fire Company shows the engine house and bell tower, which is located on High Street and is a part of Phoenixville's north side. Although some modifications have been made to the building over the years, much of the original structure is intact.

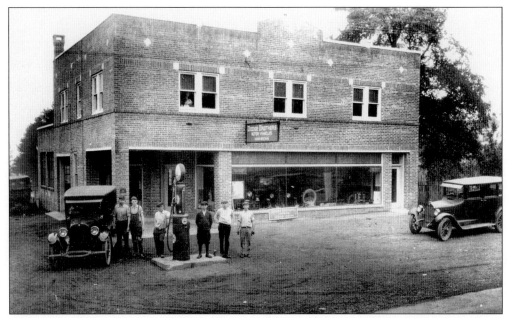

The Dodge Brothers Auto Sales & Garage was located at the intersection of Whitehorse Road and Route 23 in 1926. Despite alterations and renovations over the years, part of the original structure remains today and is now home to a bank. (Courtesy of the Historical Society of the Phoenixville Area.)

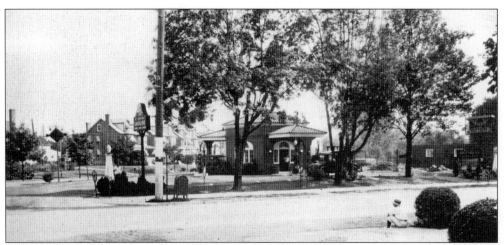

This 1920s photograph shows the corner of Nutt Road and Gay Street. A service station was located on the property of what is now Gateway Pharmacy. Notice the Spanish-tiled roof on the building and vintage gas pumps on both sides. The homes in the background on Fifth Avenue are still there today and look much the same now as they did then. (Courtesy of the Historical Society of the Phoenixville Area.)

# Two
# BUSINESS AND INDUSTRY

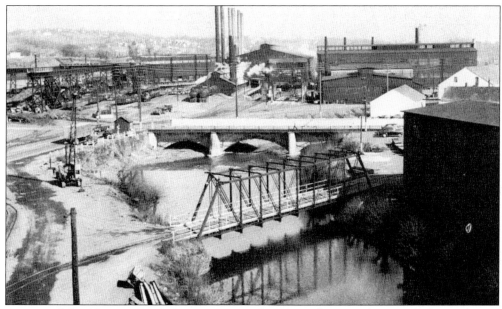

A view of the Phoenix Steel Corporation in the 1940s shows a Phoenix Bridge Company bridge, with Main Street lying just beyond it. All of the buildings seen in this image have been demolished over the years. Only the bridge remains.

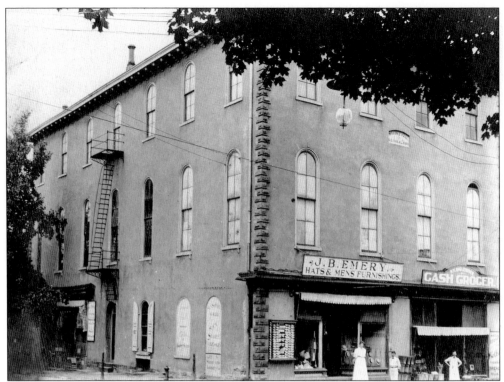

A 1908 photograph of the Masonic building shows the Emery and Anglemoyer businesses. Built in 1868, the Masonic building has stood prominently over Phoenixville's landscape for parts of three centuries.

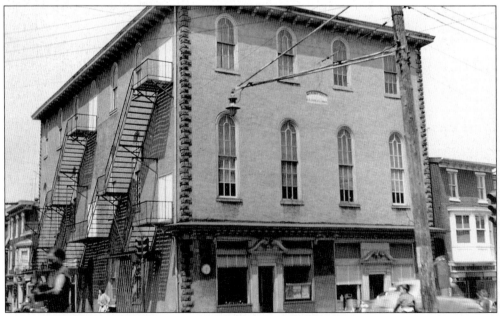

This early-1950s photograph of the Masonic building, located on Main Street at Church Street, shows the building's transformation from having retail stores in its storefronts to having offices.

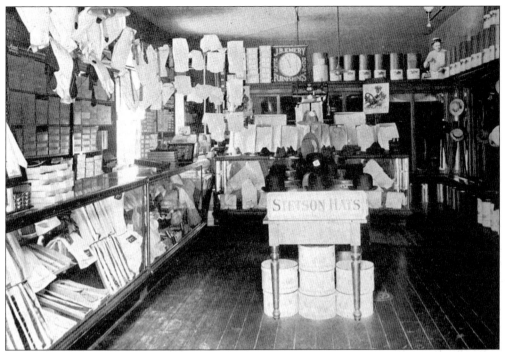

A 1909 photograph shows the interior of the J.B. Emery store for "Men's Hats & Furnishings." A display for Stetson-brand hats can be seen in the foreground.

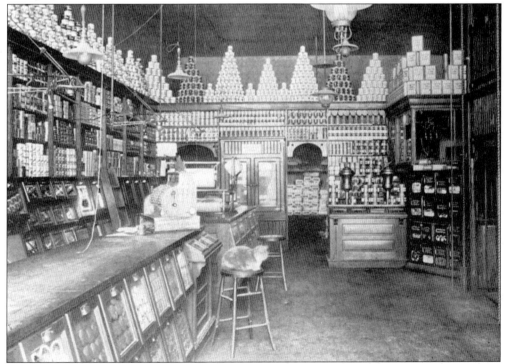

This is a 1910 photograph of the interior of the Anglemoyer Cash Grocery, located at the base of the Masonic building.

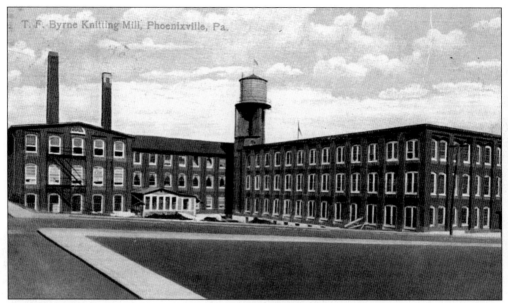

A postcard from 1911 shows the Byrne Knitting Mill, located along Morgan Street between Lincoln Avenue and Buchanan Street. The building is still in use today as a business complex. The original structure is largely intact, with the exception of the wooden water tank, which was removed in the late 20th century.

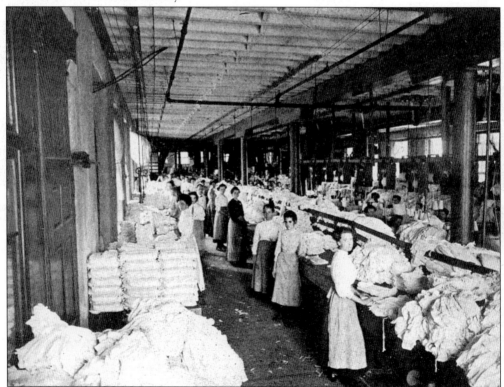

A 1910 photograph shows the finishing room at the Byrne Knitting Mill. The firm was able to manufacture thousands of pairs of undergarments and shoelaces each day.

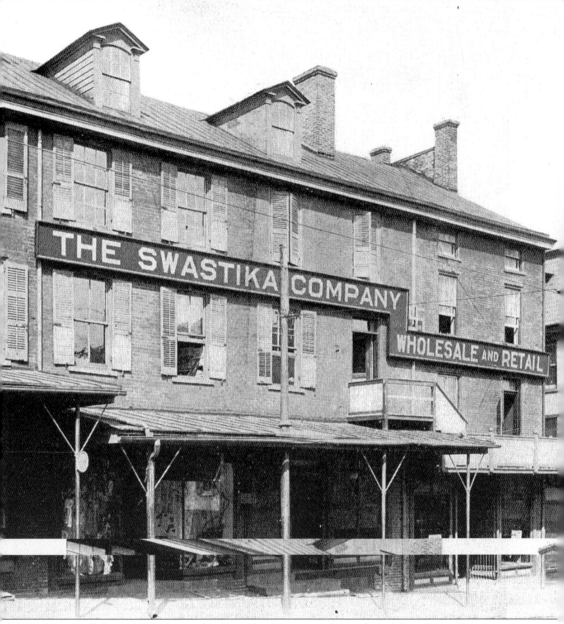

This photograph from 1910 shows the Swastika Company, located on Main Street between Bridge and Prospect Streets. Despite the indelible notoriety attached to it as a result of the Nazi party, the swastika had traditionally been a symbol of good luck, and the firm was able to sell a variety of retail goods. Although the porches have been removed, the buildings are still located on Main Street today.

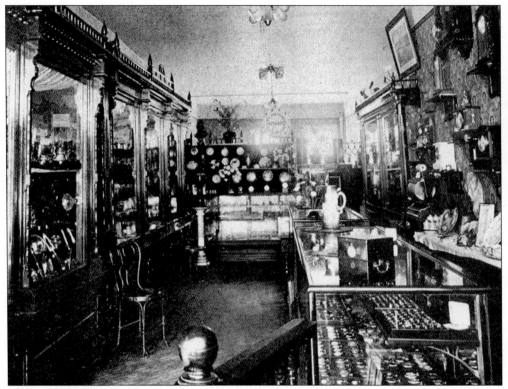

An interior view shows the Deininger Jewelry Store, located at 21 Main Street, a few doors up from Prospect Street. The building is still there, although the interior would be unrecognizable from this 1909 photograph.

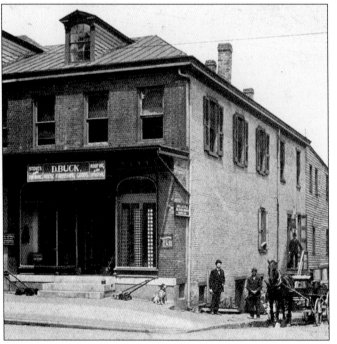

A 1910 photograph shows the David Buck Store for Home Furnishings, Stoves, and Heaters. This building is located on Bridge Street at Bank Street in downtown Phoenixville. Despite some alterations, the original structure still resembles that in the photograph.

Klenk Dry Goods was located at 246 Bridge Street. The business stocked a variety of cotton and linen garments. The building remains today, and the original structure appears much the same now as it did in this 1910 photograph, except for the porch having been removed.

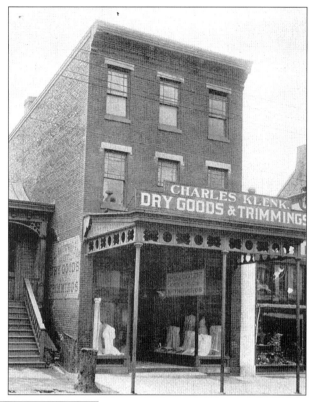

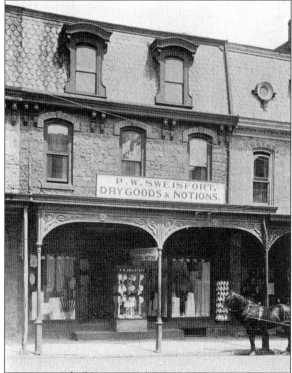

P.W. Sweisfort Dry Goods & Notions was located at 215 Bridge Street in 1911. The business carried a high-class stock of silks, woolens, and dress materials. Although the porch was removed long ago, the building has retained much of its original stone structure and facade.

The Kremer Jewelry store is seen in this 1910 photograph. The business was located at 241 Bridge Street and is currently the home of Troxell's Jewelry Store.

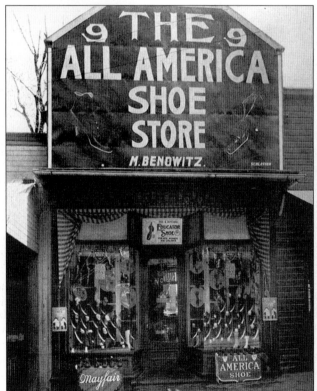

The All America Shoe Store, owned by Morris Benowitz, was located at 9 Main Street. The building was just down from Prospect Street and today is the site of a municipal parking lot.

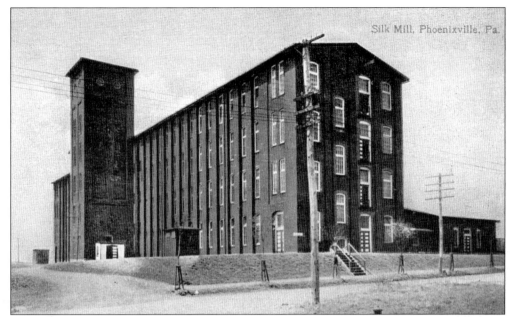

The Johnson-Cowdin Company Silk Mill was located along Franklin Avenue at Grant Street on the north side of Phoenixville in 1906. Years later, the building would be used by the Lachman Carpet Company and the Budd Company. The complex is still in use today, and the original silk mill building is no longer recognizable.

Parsons & Baker Manufacturing was located in a building near Lincoln Avenue between Walnut and Hall Streets in 1909. A manufacturer of undergarments, the firm employed hundreds of residents over its decades of existence. The building is still there and has retained much of its original structure. The homes to the right were later demolished and are now a parking lot.

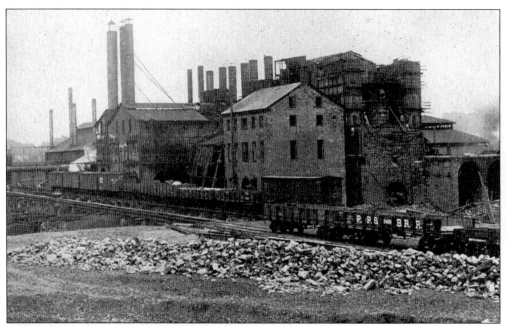

The old blast furnace at the Phoenix Iron Company is shown in this late-19th-century photograph. The roof of the Main Street foundry building can be seen behind the building and to the right. This grouping of old buildings was torn down long ago.

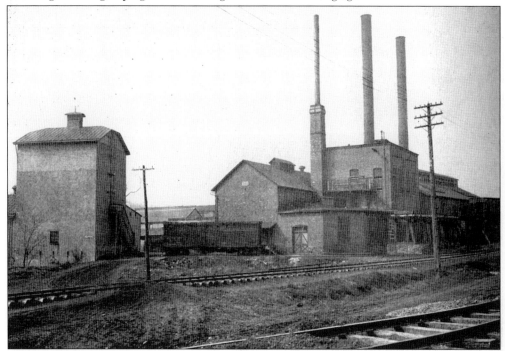

This 1908 photograph shows the Phoenix Ice Manufacturing Company. This plant was integral in its role of producing blocked ice to be delivered by horse-drawn carriage and used in iceboxes. It was located near the intersection of West Bridge and Wheatland Streets, having been demolished long ago.

The John Smith business was located on Bridge Street at Main Street in 1912. The firm was a clothing store supplying residents with hats, neckwear, and general men's haberdashery. The building would house a variety of businesses over coming decades before being destroyed by fire in 1970. The site is now home to a small park crowned by the Phoenixville mural.

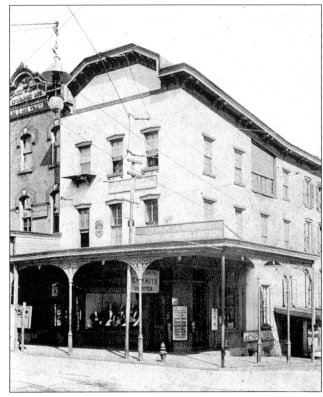

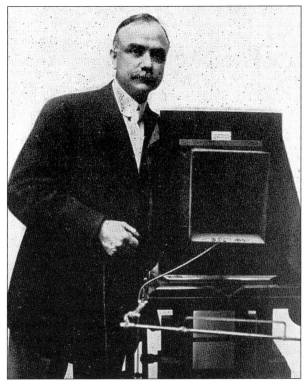

J.W. Sigman was one of the few photographers serving Phoenixville as the community experienced its most explosive growth. His studio was located at the corner of Main and Bridge Streets. He is seen here with a vintage camera and is responsible for many of the photographs that help to relate Phoenixville's history. Starting out in the late 19th century, J.W. Sigman worked continuously into the 1960s.

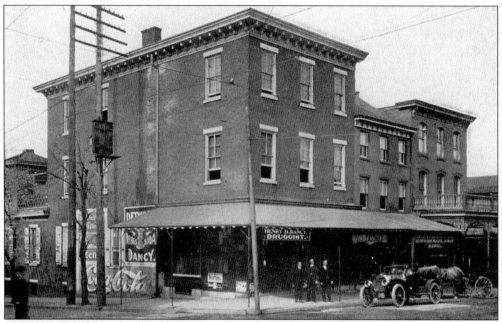

The Dancy Drugstore was located at the corner of Bridge and Main Streets in the building now occupied by Seacrist's. This 1909 photograph shows a row of buildings facing Bridge Street, all of which are still there today. The porches were removed decades ago, as were the painted signs emblazoned on the Main Street side of the building.

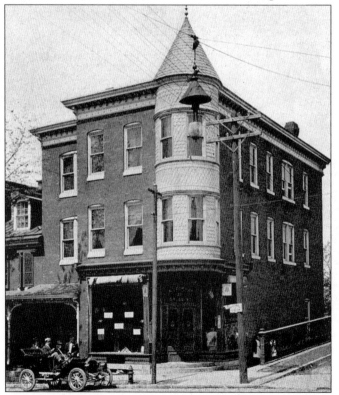

Dorman's Drugstore is seen in this 1910 photograph. The building still stands at the corner of Bridge and Gay Streets. The small building to the left is also still there and, despite some modifications, the building's structure remains largely intact. The Gay Street Bridge can be partially seen at the right.

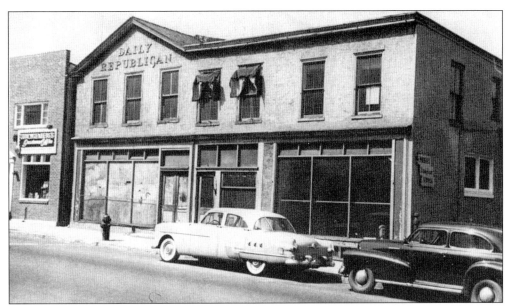

The *Daily Republican* was the precursor to the *Evening Phoenix* newspaper. This 1950s photograph shows the newspaper's headquarters on East Bridge Street, on what is now the site of the district court. This location served the organization until larger quarters could be secured farther up Bridge Street in what once was the National Bank of Phoenixville building. (Courtesy of Larry Swartz.)

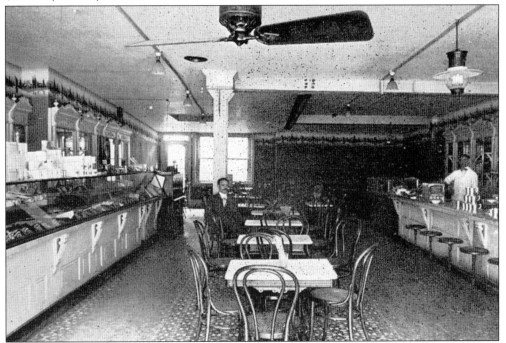

The Phoenixville Candy Company was located at 208-210 Bridge Street in 1910. This photograph shows the interior of the store, which sold chocolates, ice cream, and fountain sodas. The property would later spend decades as Dell's restaurant and banquet facility. The building is still there, but the interior is completely unrecognizable from this photograph.

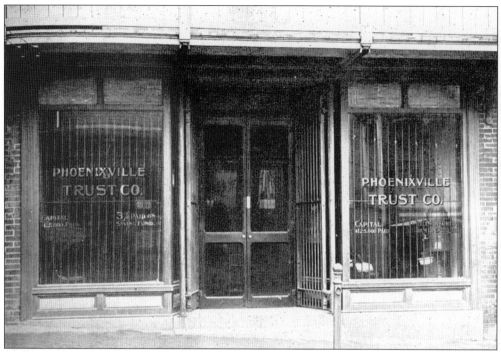

A 1910 photograph shows the facade of the Phoenixville Trust Company—one of the few banks servicing the growing community's needs in the early 20th century. The Phoenixville Trust Company was located on Main Street at Church Street and is no longer in operation.

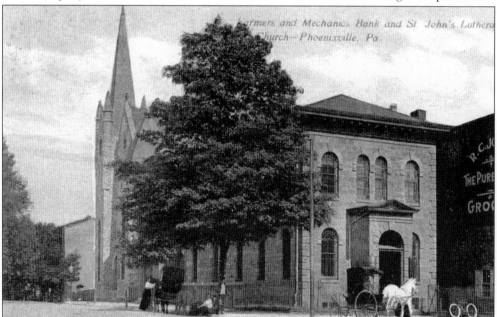

A 1907 postcard shows the original Farmers and Mechanics National Bank building. Located at Main and Church Streets, this building served as the bank until the current structure was erected in 1925. A grocery store is visible at the right, and St. John's Lutheran Church can be seen in the background.

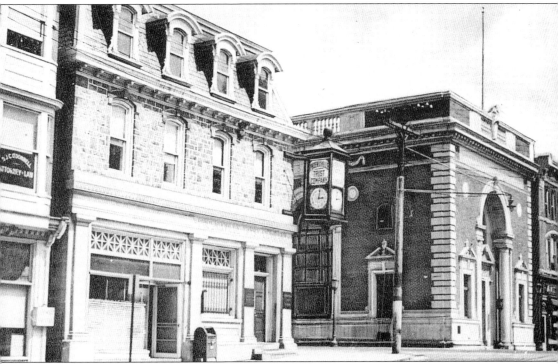

This 1937 photograph shows the intersection of Main and Church Streets. Farmers and Mechanics National Bank is shown on one corner, with the Phoenixville Trust Company on the other. Both buildings remain today, with little alteration having been done to their structures. The clock hanging from the Phoenixville Trust Company was removed long ago, but the other buildings on the block are all still there.

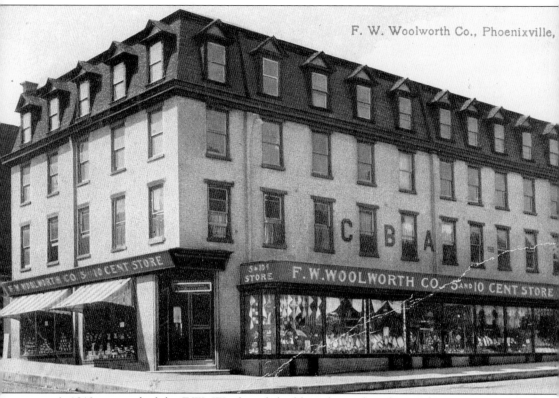

A 1913 postcard of the F.W. Woolworth building, located at the southwest corner of Bridge and Main Streets, advertises the company's commitment to five-and-dime prices. The large business served Phoenixville residents at a time when the town was experiencing substantial growth, and demand for consumer goods was increasing. The original structure has been altered over the years and is currently a row of two-story storefronts along Bridge Street.

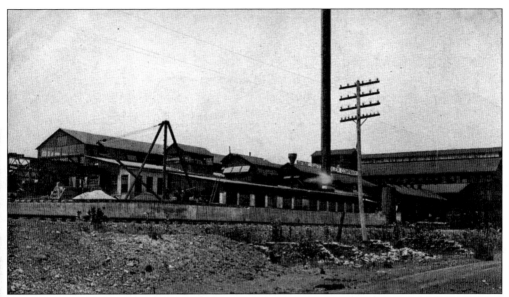

The Heine Safety Boiler Company is shown in this 1918 postcard. This structure was located off Second Avenue near Manavon Street and has been vastly altered over the years as new industrial tenants occupied it. The Heine Boiler Company was headquartered in St. Louis, but the Phoenixville location was integral to the company's long success.

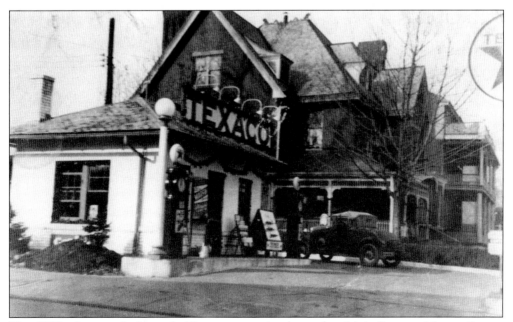

This 1930s photograph shows the Texaco gas station located on Main Street at Morgan Street. The gas station was torn down years ago to make way for a beverage distributor. (Courtesy of Larry Swartz.)

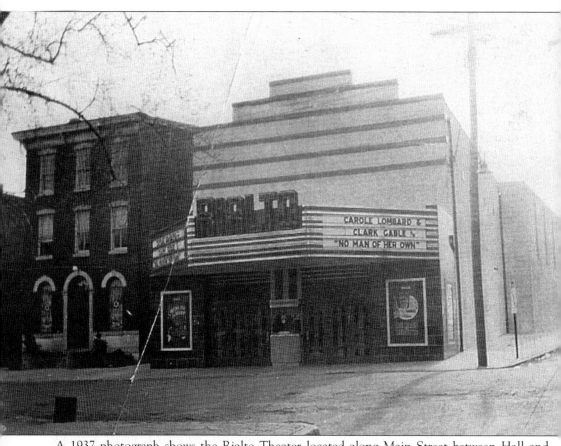

A 1937 photograph shows the Rialto Theater located along Main Street between Hall and Walnut Streets. The theater was torn down decades ago, and a YMCA was built in its place. Today, a bank sits on the lot that was home to the Rialto. (Courtesy of Larry Swartz.)

This 1908 photograph shows the Phoenix Iron Company building along East Bridge Street. The building is still there today and retains much of its original structure.

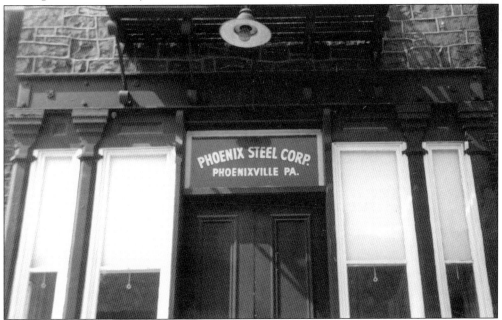

A photograph from 1987 shows the name of the Phoenix Steel Corporation painted on glass, over the door of the building. These were the last days of a once mighty and prosperous business that dominated Phoenixville's industrial landscape and identity for so many years. The glass bearing the Phoenix Steel Corporation's name was removed shortly after this photograph was taken.

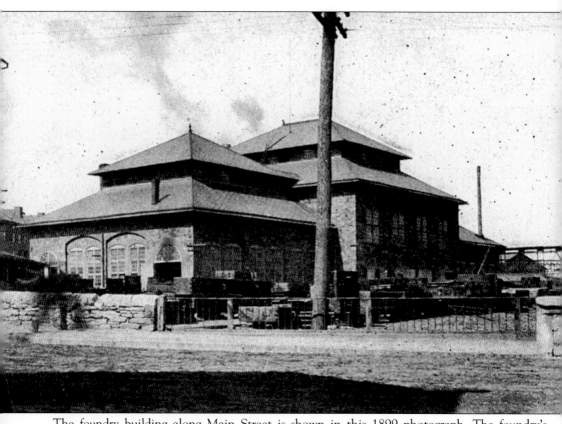

The foundry building along Main Street is shown in this 1899 photograph. The foundry's interior was the epitome of late-19th-century industrial efforts. A network of pulleys, beams, and other apparatus were as much a part of the building's fabric as the structure itself. The wall lining Main Street was removed many years ago, but after a restoration effort beginning in the late 1990s, the foundry is starting to look much the same now as it did then.

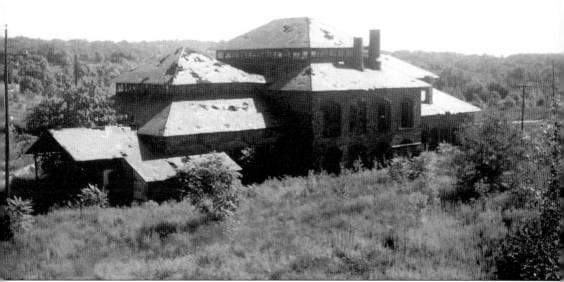

A 1994 photograph taken from the Gay Street Bridge shows the foundry building in a state of disrepair. The property is overgrown, the slate roof is full of holes, and the inside of the building is strewn with debris and industrial waste. In just a few short years, renovations would begin, aimed at restoring the building to its former glory and making it usable again.

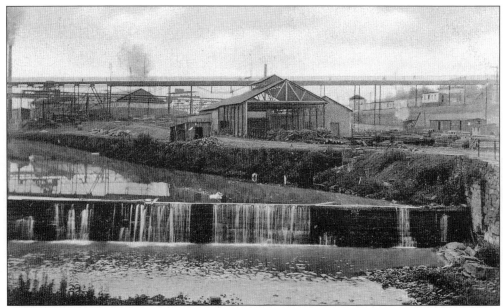

A 1911 postcard shows a view of the Phoenix Iron Company property as seen from the Main Street Bridge. The dam and Gay Street Bridge are also visible in the background. The dam has been drastically reduced in its size and role, and all of the buildings in this image have been razed. The current Gay Street Bridge replaced the original bridge shown in 1924.

An old train is shown as it crosses Main Street in the 1930s. The front of the train is emblazoned with the name Phoenix Iron Company. Trains were used not only to ship raw materials and finished product to and from the site, but also to ferry iron in various stages throughout the sprawling complex. The tracks have been removed, and the old house in the background was torn down to make room for a retirement home. (Courtesy of Larry Swartz.)

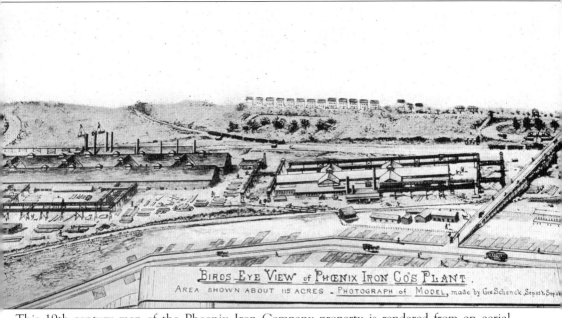

This 19th-century map of the Phoenix Iron Company property is rendered from an aerial vantage point. Shop 6 is visible in the center, and the Gay Street Bridge can be seen at the right. The area shown is purported to be 115 acres, according to the architect's note. In later years, the business would extend from the Schuylkill River in the east, to beyond Mason Street at the western end of town.

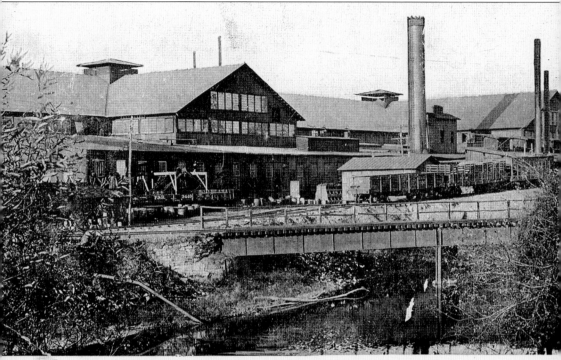

SHOP 6 PHOENIX IRON CO., PHOENIXVILLE, PA.      PUBL. BY R. G. SHAFFE

A postcard from 1910 is labeled, "Shop 6." The building's approximate location spanned the length of the steel property beyond the 300 block of Bridge Street and was demolished in the late 1990s. The bridge in the foreground is still in place, although hanging precariously over the creek.

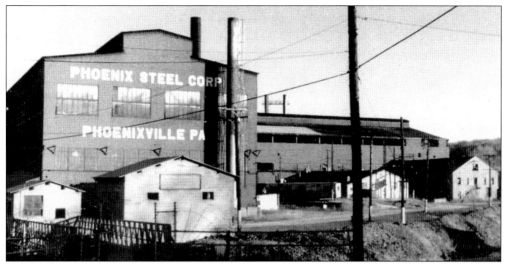

This 1986 photograph shows the Phoenix Steel Corporation near its final days, shortly before being torn down. This building was located behind the administration building on East Bridge Street. All of the smaller buildings were also razed in the effort to make the lot usable for a variety of purposes.

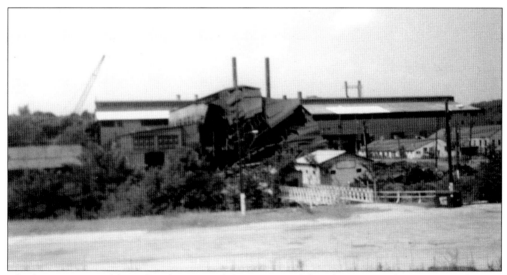

The late 1980s would see the almost total destruction of the Phoenix Steel property at the east end of town. In this 1988 photograph, the building pictured above is in the process of being demolished.

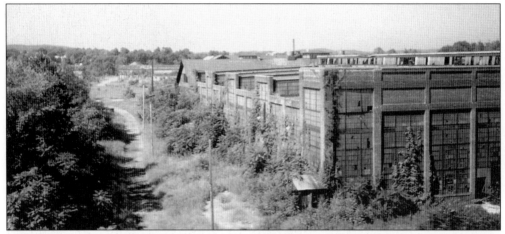

This photograph from 1994 shows the east end of what was Shop 6. Although Shop 6 was constructed mostly of metal, this section built later was comprised mostly of brick. An intricate network of indoor cranes and mechanisms for moving steel once graced the underside of the massive ceiling. By the time of this photograph, the dilapidated condition of the building was evident through the broken glass and overgrown weeds. It was torn down in the late 1990s.

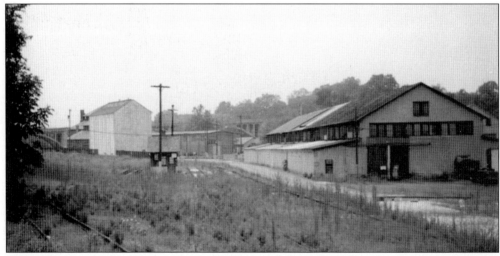

This 1987 view of the Phoenix Steel property was taken from the area of Bridge Street and Church Alley. Train tracks, a small guardhouse, and other buildings, including the large building in the background that housed the infirmary, are all visible. The buildings were all torn down shortly after this photograph was taken. The Gay Street Bridge is visible in the distance.

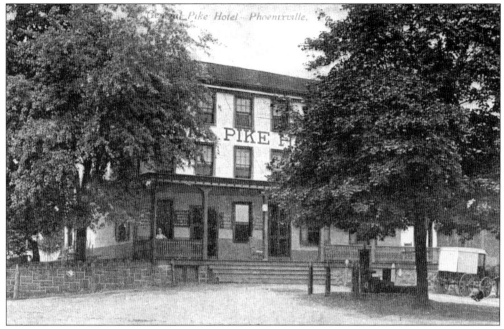

A postcard from 1903 shows the General Pike Hotel when it was sitting amidst a rural landscape. Little development had taken place in the area of Route 113 and 23 at that time, and the business served boarders, food and beverage, and civic needs for many years.

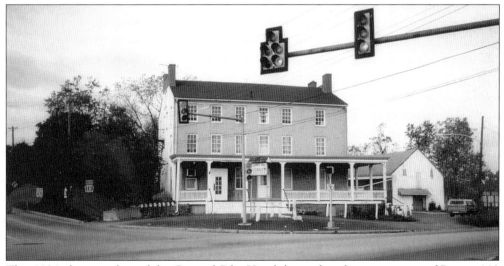

This 1994 photograph is of the General Pike Hotel, located at the intersection of Routes 113 and 23. The hotel served as Phoenixville's first post office in the early 1800s. It was torn down in the late 1990s despite protests regarding its historical value to the community and is an empty lot today.

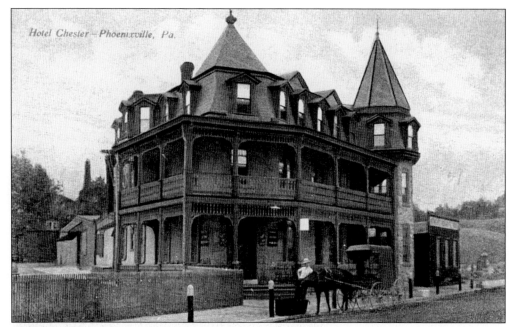

The Hotel Chester is seen in this 1905 postcard. The building has served as a hotel, restaurant, and bar among its many incarnations over its century-long existence. In this image, a horse-drawn cart is situated next to the hotel's entrance at what is now the corner of Bridge and Church Streets. The building to the right was torn down long ago, but the hotel retains much of its original charm and design to this day.

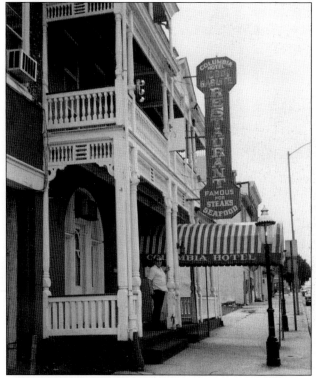

A 1988 photograph shows the Columbia Hotel on East Bridge Street. The building has served Phoenixville as a hotel, bar, and restaurant for more than 100 years almost without interruption. The hanging sign advertising an "1890s gaslite" can be seen on the building's facade but has since been removed. Currently, a massive renovation has restored the building to its former glory. (Courtesy of John Martino.)

The Jefferson House Bar and Hotel is seen in this 1925 photograph. The building was built near the middle of the 19th century and still stands on High Street at the foot of South Street, although it has been converted to an apartment building.

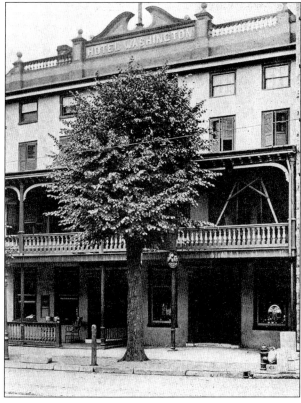

The Washington Hotel is seen in this 1909 photograph. The building is located along Bridge Street immediately to the Colonial Theater's right and has also functioned as a bar and restaurant for decades. The building is still operated much the same and continues to serve Phoenixville's citizens and those passing through.

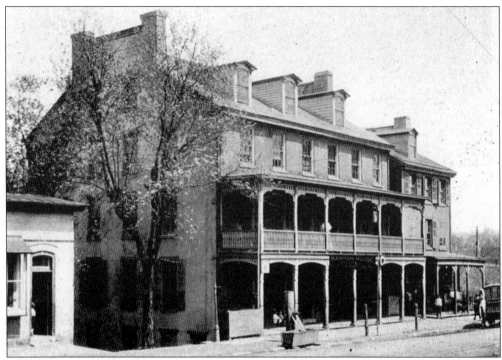

The Mansion House is shown in a 1911 photograph. Located along the eastern end of Bridge Street, the hotel has operated for more than a century in much the same capacity. The buildings on each side of the hotel were torn down many years ago, but the Mansion House retains much of its original structure inside and out to this day.

The Bull tavern is seen in this 1950s photograph. Built in 1734, the tavern functioned under the same name decade after decade until it was closed in the late 1980s. Banquets, dinners, and drinks were served in its many rooms in a continental atmosphere reminiscent of the late 18th century. Today, the building houses a few different businesses, including a restaurant, and has retained much of its original external structure.

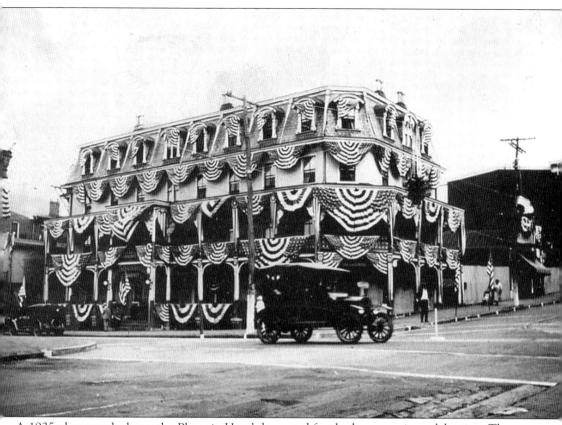

A 1925 photograph shows the Phoenix Hotel decorated for the homecoming celebration. The hotel was located on the southeast corner of Bridge and Main Streets. Over its half-century existence, it played host to many important social events in Phoenixville. The hotel was demolished in 1949 and replaced with W.T. Grant's, a variety store. Today, the site is a parking lot. (Courtesy of Larry Swartz.)

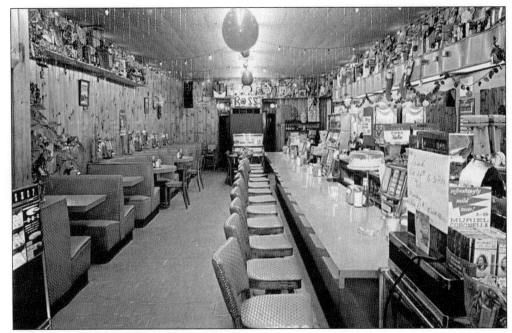

This postcard of the Trio was taken during the holidays in the 1950s. The caption on the card touts the restaurant's fast, courteous service and its ample free parking.

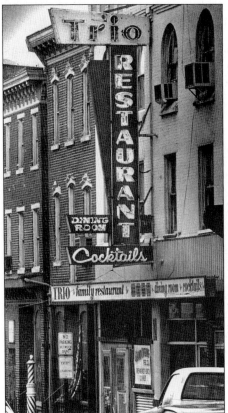

The Trio restaurant was located at 178 Bridge Street for many years before closing finally in the mid-1980s. A combination of being open 24 hours each day and the proximity of the steel company made the Trio very successful. The actual building is still there, but the exterior is unrecognizable from this image.

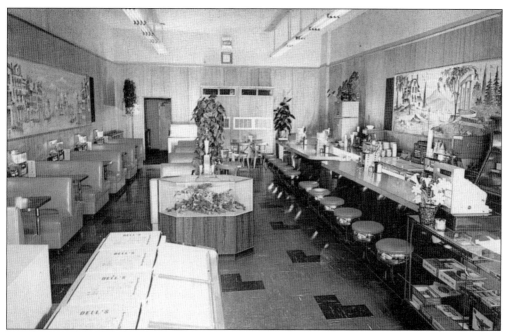

The inside of Dell's Pizza & Sandwiches is pictured in the early 1960s. Dell's was located at 205 Bridge Street. It is another example of local business profiting from the influx of hungry lunchtime customers, courtesy of Phoenix Steel. As business grew, the luncheonette and pizzeria was expanded to a full-service bar, restaurant, and banquet facility just across the street.

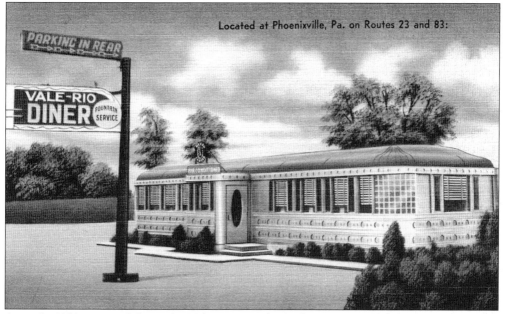

An early-1950s postcard shows the Valerio Diner, located on Nutt Road near Bridge Street. An interesting note is that the card gives the location as Route 23 and the now-defunct Route 83. The diner's consistent food and 24-hour convenience has kept residents and those passing through coming back for decades.

59

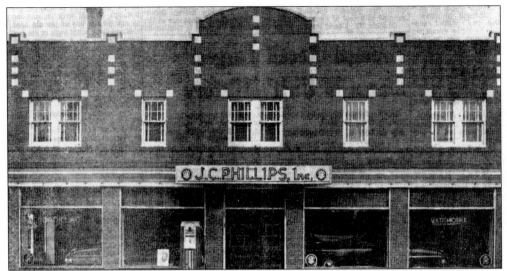

Phillips Incorporated, dealing in Cadillacs and Oldsmobiles, is seen in this 1947 photograph. The building was previously home to Unger Chevrolet until it was relocated to Nutt Road. Nardi's Pizzeria would occupy the building for years after it became impractical for auto sales. The building can still be seen along West Bridge Street at Buchanan Street.

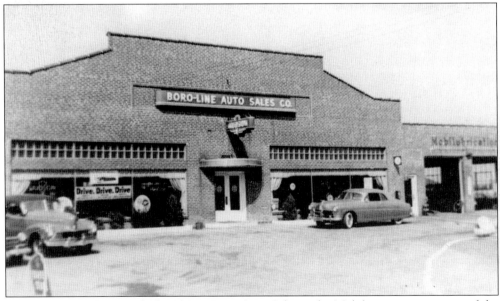

An early-1950s photograph shows BoroLine Auto Sales and a Mobil gas station as part of the same facility. This building was located along Route 23 and was later occupied by a bike store before being torn down in the late 1990s to make way for what is now a shopping center. (Courtesy of Larry Swartz.)

# Three
# GROWTH AND PROSPERITY

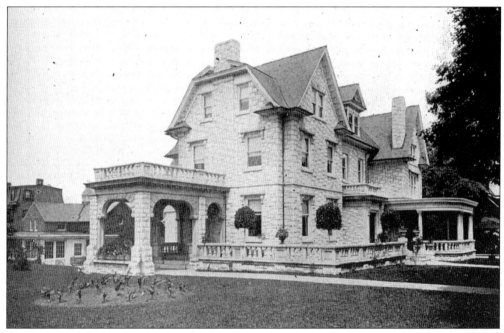

The Byrne family residence is seen in this 1911 photograph. The Byrne family was responsible for the construction of St. Ann's Catholic Church, which was made possible by the success of their knitting mill. This house is located on Main Street at Second Avenue and is no longer a private residence, having been converted to office space. The overhead porch in the front exists no more, and the carriage house visible in the back was torn down long ago to make room for a parking lot.

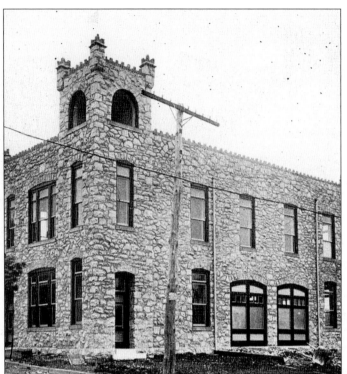

A 1909 photograph shows the West End Fire Company as it was under construction. The building is located along West Bridge Street at Pennsylvania Avenue. Although subsequent additions and alterations were made to the original structure over the years, the building looks very similar now as it did then.

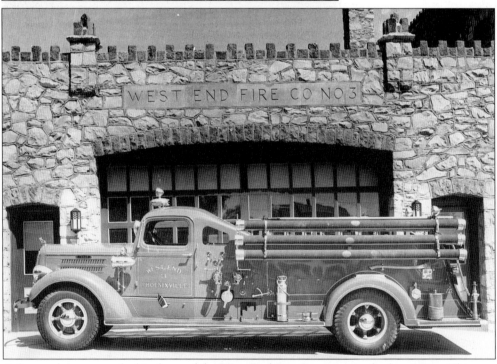

A fire truck is seen parked in front of the West End Fire Company in the late 1940s. This part of the building faces West Bridge Street and still looks almost exactly the same today. (Courtesy of Larry Swartz.)

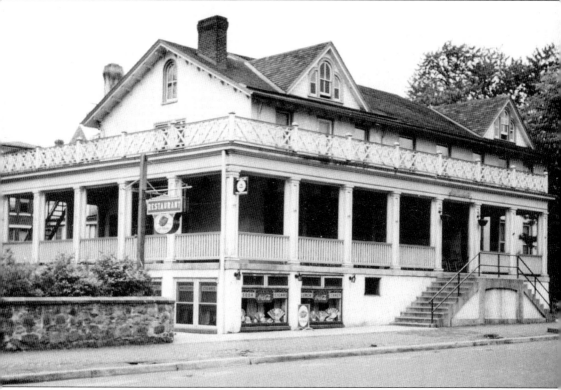

This early-1950s photograph shows the American Legion Post building, located on Main Street between Washington Avenue and Morgan Street. The American Legion served the many veterans of Phoenixville as an important and central meeting place. In this photograph, a small store is visible at ground level also. The building was torn down decades ago, and the site is now a parking lot. (Courtesy of the Historical Society of the Phoenixville Area.)

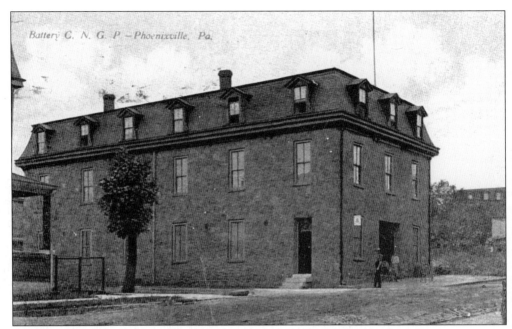

This 1918 postcard shows the Battery C building, located on Buchanan Street at Morgan Street. The building sat directly in front of the armory, also located on Buchanan Street. The Borough of Phoenixville now occupies the armory building, and most of Battery C was torn down in the mid-1980s to create additional parking.

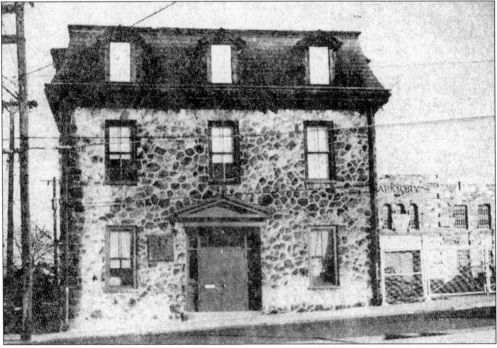

A photograph from the late 1970s shows the Battery C building in the decade before it would be torn down. The armory building can be seen clearly in the background at the right and is the only one of the two still standing.

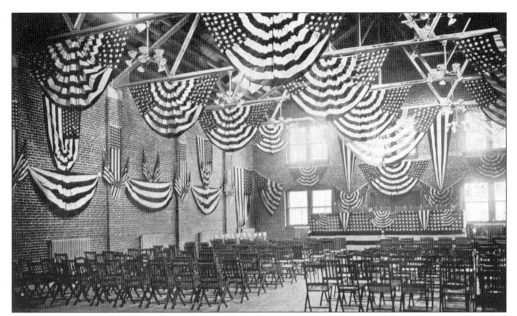

A 1912 photograph shows the interior of the armory building, located along Main Street at Hall Street. The armory played a crucial role as a gathering spot for servicemen during World War I. The building is now occupied by the Phoenixville Civic Center. Although the interior has been altered quite a bit since this photograph, the building's exterior looks much the same.

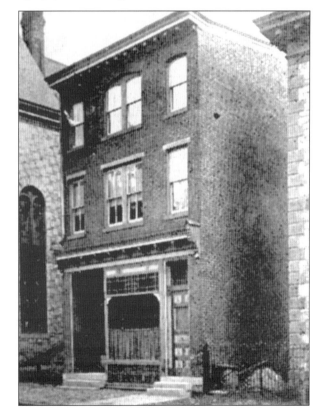

This 1910 photograph shows the Phoenixville Club, which was located along Church Street directly behind Farmer's and Mechanics National Bank. The club was social in nature, and many members of Phoenixville's business and professional men would gather for discussions, billiards, and relaxation. This building was later razed in order to construct the new bank building in 1925.

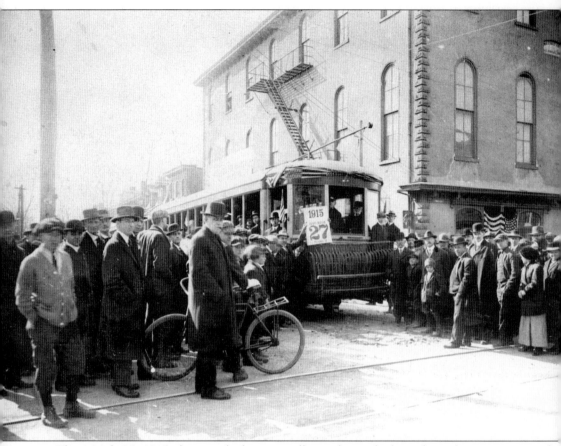

This March 27, 1915 photograph shows a trolley and crowd of people at the intersection of Church and Main Streets. The Masonic building is visible in the background. Residents of all ages turned out on this chilly day in early spring to watch the trolley as it climbed its way up Church Street. The tracks in the middle of Main Street were torn out long ago, but the Masonic building in the background looks much the same today. (Courtesy of Larry Swartz.)

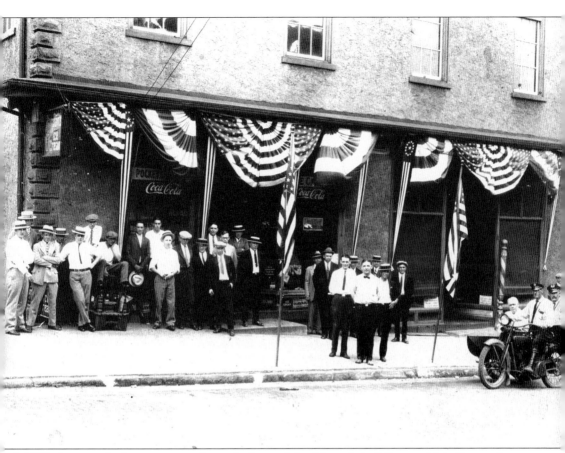

A 1925 photograph shows a group of men in front of the Masonic building on Main Street. A couple of policemen sit idle on a motorcycle, and the signs in the storefront windows advertise Coca-Cola and the availability of pocket billiards. A barber pole at the right indicates the type of business located in the second storefront. At the left, a man can be seen sitting on a chair meant to facilitate in shoe shining. (Courtesy of Larry Swartz.)

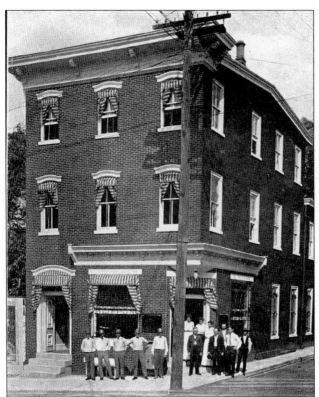

The Phoenixville Post Office is seen in a 1911 photograph. This building is located on Main Street at Prospect Street. The facility would serve the postal needs of a growing community for years before the institution could be moved to its current location on Gay Street. In those days, a post office's location would often change with each new postmaster.

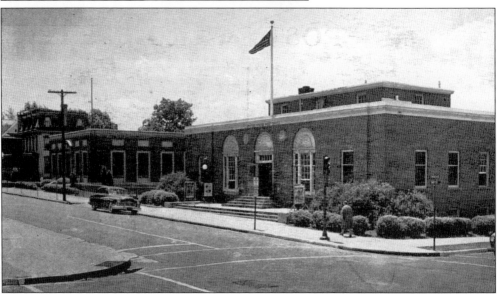

A 1939 photograph shows the post office on Gay Street at Church Street. This facility was built to accommodate the burgeoning postal needs of Phoenixville's fast-growing community. Subsequent acquisitions of neighboring homes would allow for expansion and additional parking at the site. Currently, the post office still operates out of this building and, with the exception of more accessible entrance ramps, the facade looks much the same today as it did in the late 1930s.

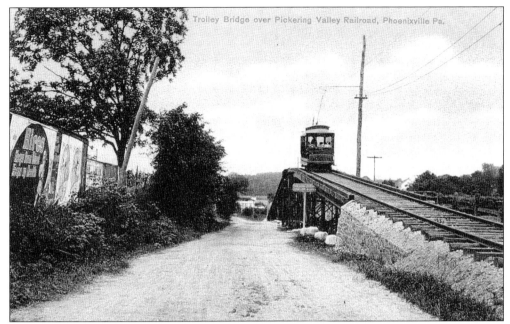

A 1912 postcard of the "Trolley Bridge over Pickering Valley Railroad" shows a trolley going over an elevated track. Notice the old advertising signs on the fence at the left, meant to lure travelers into town when their destination is complete. This image was taken in the area of what is now a shopping complex along Route 23 at the intersection of Route 113.

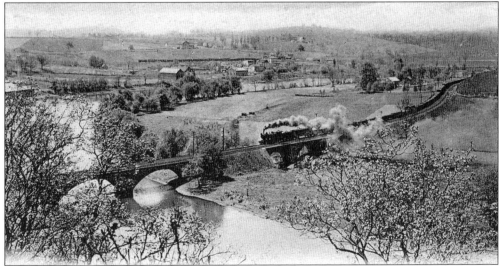

This postcard from 1906 shows a Pennsylvania & Reading Railroad train steaming along the tracks over the Schuylkill River. This noticeably rural area is in the vicinity of what is known as "Black Rock," along Route 113 north in Phoenixville.

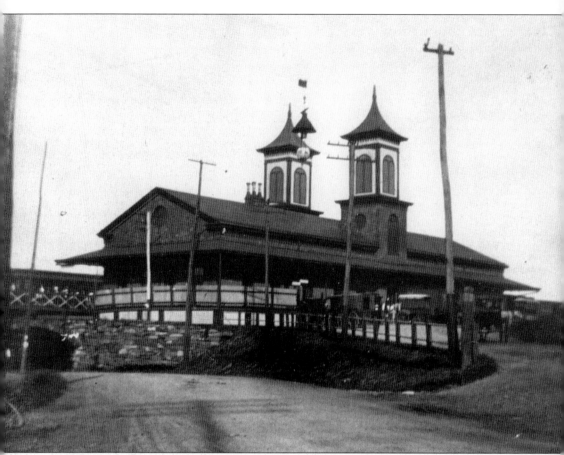

A 1909 photograph of the Philadelphia & Reading passenger station shows a facility that was integral to the growth of Phoenixville as an important commercial and residential community. The station is located along the Schuylkill River at the end of Bridge Street. In this photograph, horse-drawn carriages await the arrival of passengers so their journey can continue. The station now functions as a catering hall and, with the exception of the two large steeples adorning the station's roof, it looks much the same today as it did then.

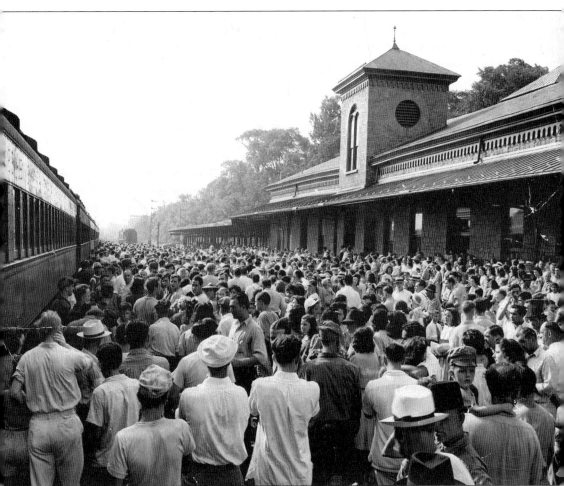

This 1942 photograph shows the crowded platform outside of the Philadelphia & Reading passenger station. Young men from the community are boarding the train en route to military training bases all over America to aid in the war effort. A montage of faces conveys the mixed emotions with which families bid farewell to sons, husbands, and brothers in what would certainly be an arduous journey into uncertainty. (Courtesy of Larry Swartz.)

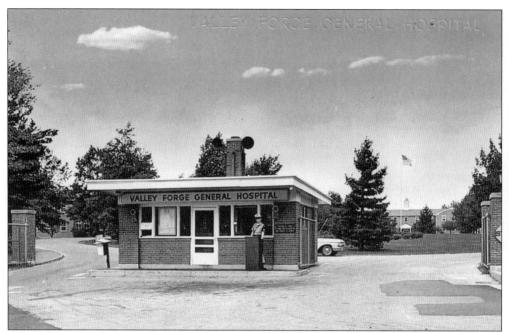

A 1960 postcard shows the guardhouse at the entrance of the Valley Forge General Hospital. The hospital served the needs of servicemen from all over the nation. After the end of the Vietnam War, there was less use for the hospital and it was closed. The guardhouse that sat along Charlestown Road was torn down in the early 1990s.

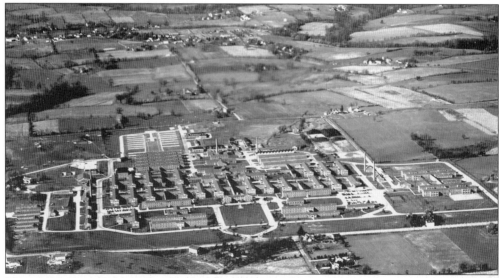

This aerial view of the Valley Forge General Hospital was taken in the 1940s. The site was comprised of many buildings that housed living quarters, medical facilities, and recreation areas. There was also a movie theater, bowling alley, and golf course all on site. As military cuts became more prevalent in America, the hospital was closed and the grounds are now home to a Christian college. Many of the original buildings have survived and have been outfitted to create the collegiate setting.

This house was located at the southeast corner of Nutt Road and Gay Street. It was owned by the Pennypacker family and would later become the site of their flower shop and greenhouses. The photograph was taken in 1905 before the greenhouses were built. (Courtesy of the Historical Society of the Phoenixville Area.)

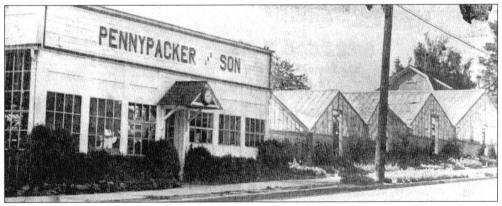

Pennypacker and Son Florist & Greenhouses can be seen in this 1940s photograph. The business was located at the southeast corner of Nutt Road and Gay Street. The building and greenhouses were torn down long ago to make room for Phoenixville Hospital expansion.

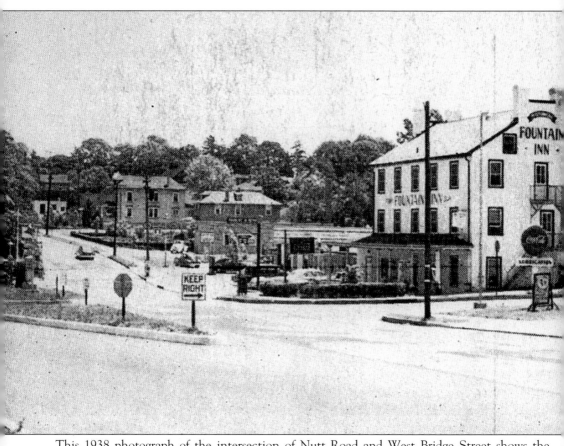

This 1938 photograph of the intersection of Nutt Road and West Bridge Street shows the Fountain Inn, ValeRio Diner, and some homes in the neighborhood. This area was known as the "Western Gateway to Valley Forge" and is marked by a monument of the farthest point reached by the British during the Revolutionary War. Notice that traffic was so light, no lights were necessary.

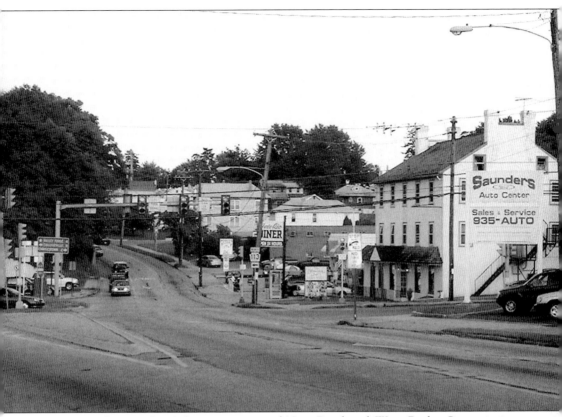

In this current photograph of the intersection of Nutt Road and West Bridge Street, it is striking how so many of the original structures are still in place years later. The Fountain Inn is still on the right, although the stone wall at its front has been removed. Traffic lights handle the remarkable volume of traffic that passes through this intersection every day. A faster-paced, commercial landscape has overtaken the genteel serenity of the past.

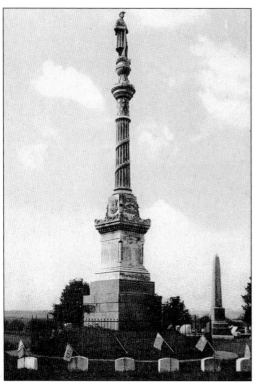

A 1905 postcard shows the Soldier's Monument located in Morris Cemetery. The monument is still visible from the cemetery grounds and vantage points along Nutt Road. It was erected in 1871 to commemorate the loss of men from Phoenixville during the Civil War.

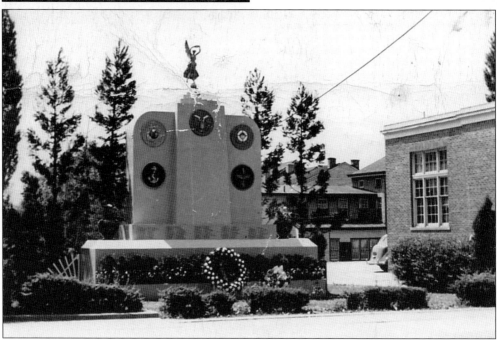

This veterans monument, pictured in the 1950s, was located along Gay Street between the post office and Bell Telephone building. This monument honored veterans of foreign war. Years ago, it was removed and never relocated when the present-day parking lot of the post office was constructed.

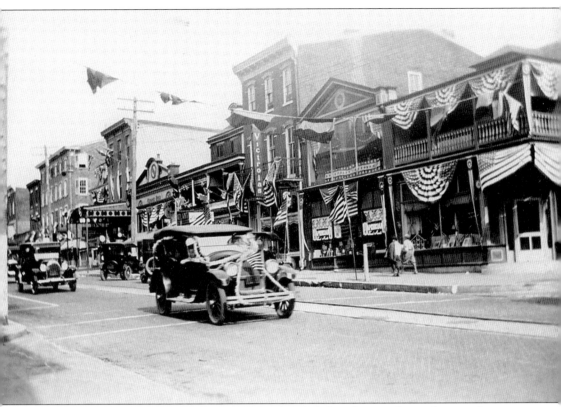

This 1925 photograph of the intersection at Bridge and Gay Streets shows the storefronts decorated for the homecoming celebration. Even the cars were decked out for this important local event, also referred to as Old Home Week. At the very right of this image, two stores can be seen that now comprise a local tavern. Immediately to their right is a furniture store whose sign advertises Victrolas, a precursor to the more modern record player. Each of the buildings shown is still there today, although 75 years of alterations have left most of them looking quite different.

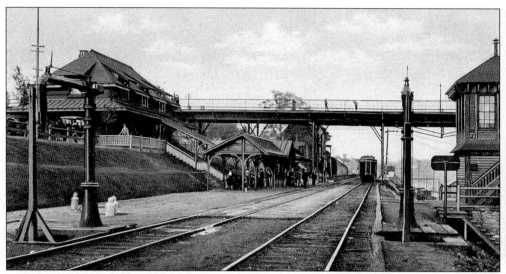

A 1910 postcard shows the Pennsylvania Railroad station located on Vanderslice Street, just to the left of the Gay Street Bridge. This was one of the few train stations that served the Phoenixville community for many years. Despite vehement protests, the shuttered station was torn down in the late 1980s to make way for a parking lot.

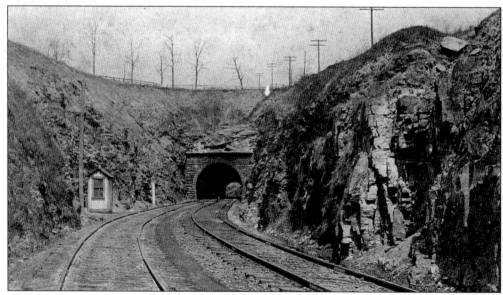

This 1911 postcard shows the Pennsylvania Railroad tunnel on Phoenixville's north side. In this image, a small guardhouse is seen at the left, while early telephone poles line the area above the tunnel. Although it has not been used in decades, the tunnel is still there, but is quite a walk from its most accessible point near High Street.

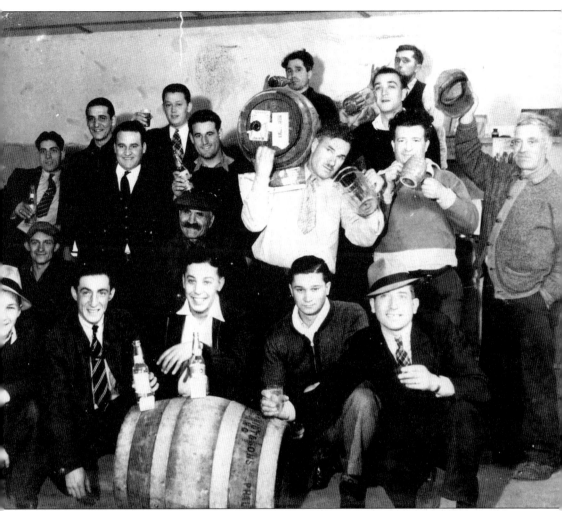

This photograph was taken in the late 1930s. Members of the St. Anna Italian-American Citizens Club are shown celebrating in the clubhouse located along Dayton Street on Phoenixville's north side. The club was founded at a time when ethnicity helped to forge ties between townspeople. At one time, Phoenixville was home to Italian, Polish, Hungarian, Slovak, and Ukrainian clubs. (Courtesy of Larry Swartz.)

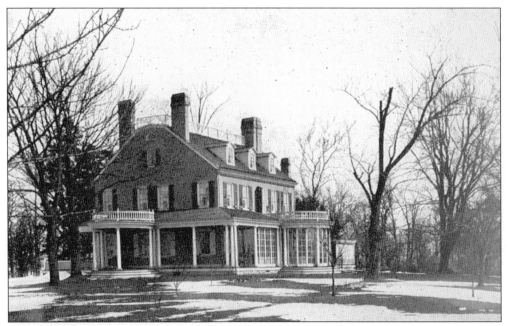

The Knoll is seen in 1906. The mansion belonged to Paul Reeves, an executive of the Phoenix Iron Company. Unfortunately, the mansion was torn down decades ago after being neglected. The Knollwood apartment complex was built in its place along Nutt Road at the southern end of Starr Street.

A 1910 photograph shows the residence of John Mull along Morgan Street, just west of Main Street. This duplex-style home is still there, and much of its original structure remains intact to this day.

The F.E. Bader home is seen in a 1909 photograph. This home is located on Main Street at Washington Avenue. It is still there and retains much of its original structure, but the trolley tracks in the street were removed long ago.

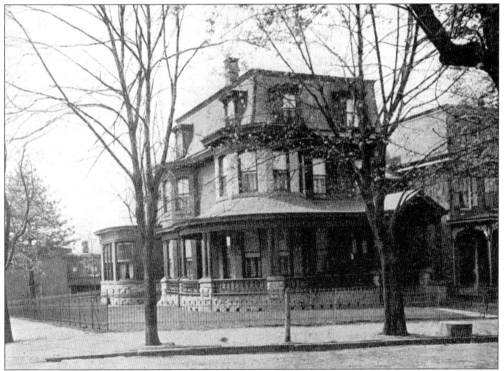

The Charles Bader residence is seen in this 1912 photograph. This grand old home is located along Gay Street at Morgan Street. It is still there today, and its exterior appears much the same, with the exception of the porch having been enclosed.

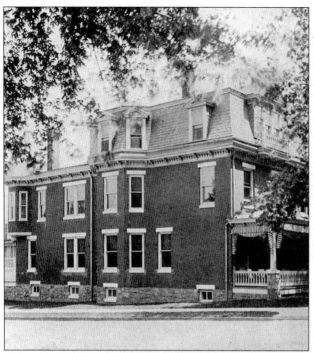

The Bitting home is seen in this 1911 photograph at the southeast corner of Gay Street and Second Avenue. It is still there today and appears much the same now as it did when it was constructed.

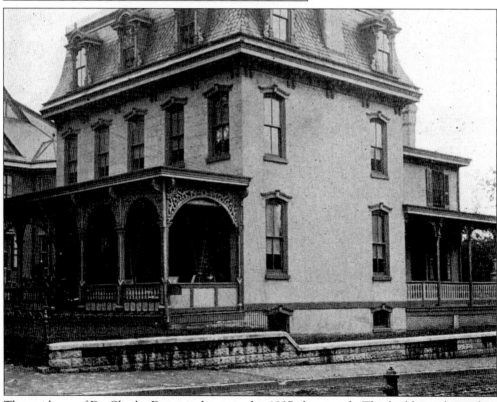

The residence of Dr. Charles Doran is shown in this 1907 photograph. This building is located on Gay Street at Hall Street and is still there today, although it has since been converted to offices.

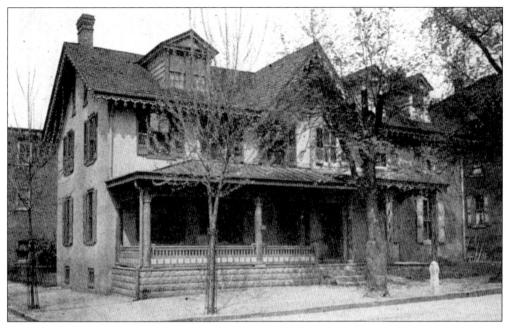

The residence of Dr. Benham is seen in this 1910 photograph. The building is located along Church Street at Gay Street and is still there today. An addition has been made to the right half of the building, and the porch roof has been removed in an effort to convert it for commercial use.

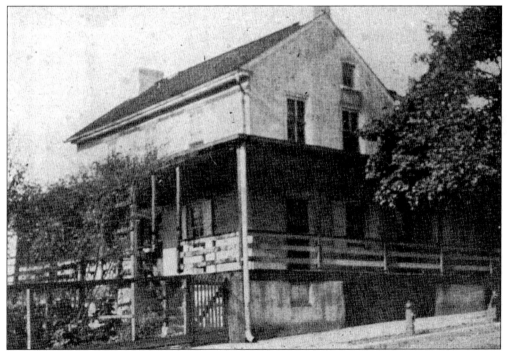

A 1918 photograph shows the McNealis house, located along Dayton Street near Route 113. It is one of the oldest residences in that neighborhood and still appears much the same way it did more than 80 years ago.

This 1932 photograph shows a car parked in front of 606 Main Street. The large house is actually a duplex, and one half is occupied as an office today. Despite minor alterations, much of the original structure and charm are retained today. (Courtesy of Larry Swartz.)

This house was located on Main Street at Fourth Avenue. It is seen here in an early-1990s photograph, shortly before it was torn down. Despite the obvious neglect in the house's appearance, many residents lamented the passing of one of Phoenixville's grandest homes. Today, the site is a grass lot next to the St. Ann's rectory.

# Four
# LIVING AND LEARNING

This is a 1952 photograph of the Gay Street School. Located on Gay Street between Morgan Street and Washington Avenue, it has served as a high school and elementary school. Many residents will recognize the familiar four-sided clock at the top of the school, visible from almost every corner in town. Today, the building has been converted into apartments and small offices. However, much of its original structure and charm remain intact.

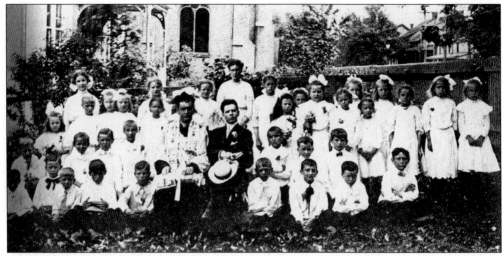

This photograph shows the Holy Communion class of 1912 at Holy Trinity Catholic Church on Dayton Street. In this image, the class sits on the lawn in front of what is now the church's rectory. The church itself is visible in the background of the photograph. More than 90 years later, Holy Trinity is still one of four Catholic churches serving Phoenixville.

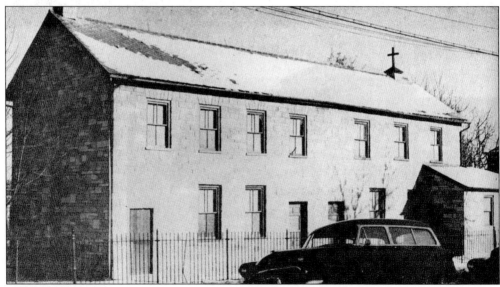

The original Holy Trinity School on Dayton Street is pictured in 1957. This school was torn down to make room for the new school, built in the early 1960s. Originally, four Catholic schools served the community's growing population of Catholics, before consolidating into one consortium amidst declining enrollment. Today, Holy Trinity's school is used for a variety of nonscholastic parish functions.

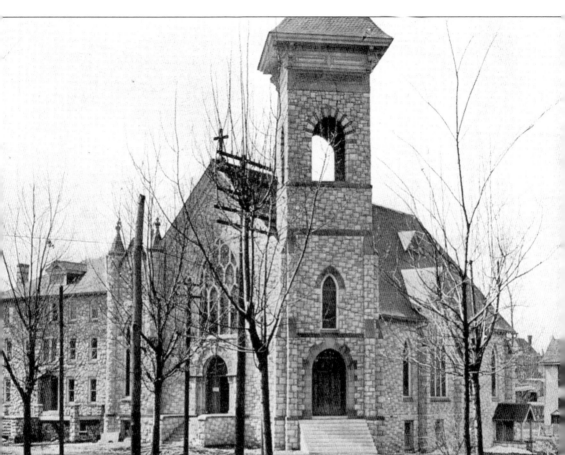

This 1906 photograph shows St. Ann's church and rectory as construction was just about complete. Located at the corner of Main Street and Third Avenue, the Catholic church was made possible by a donation from the Byrne family. The church looks much the same today as it always has, but the rectory has received minor additions over the years. The most notable addition to the rectory is the rooms added above the front porch, which was not even completed at the time of this photograph. Another interesting note is that the principle members of the Byrne family are entombed in a crypt at the rear of the church, a rare example of nonclergy being laid to rest in a church.

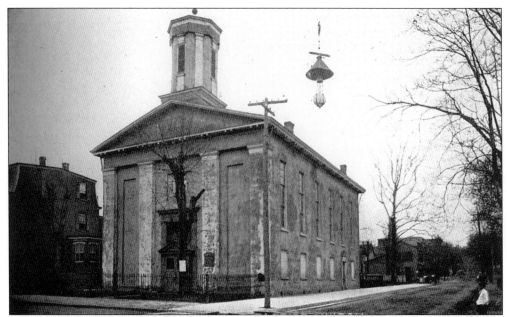

This photograph shows the original Baptist church as it stood at the corner of Church and Gay Streets in 1901. The Baptist church was just one of many churches built in the community to serve the needs of an ethnically and religiously diverse group of people. This building was torn down to make way for the new church, which is still in existence.

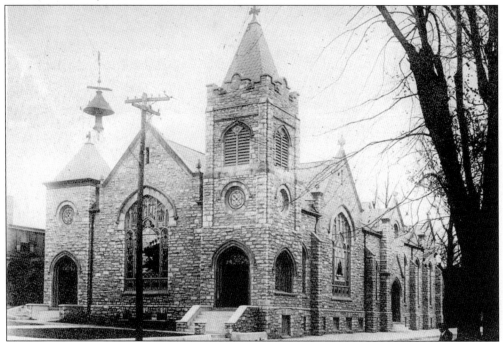

The Baptist church is seen in this photograph, taken shortly after its completion in 1911. This structure replaced the original Baptist church located on the same site. The church looks much the same today as it did then, although transparent covering has been added to protect the stained-glass windows.

A 1910 postcard shows the Hungarian Catholic Church on Church Street in what is now the location of Sacred Heart Catholic Church. Despite the presence of four Catholic churches in Phoenixville, each was home to a specific ethnic group or coupling of groups in most cases. As the parish population grew, so too did the need for a newer, more accommodating church. At the right, the brick building that was the original borough hall is visible.

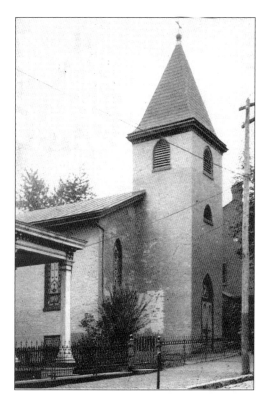

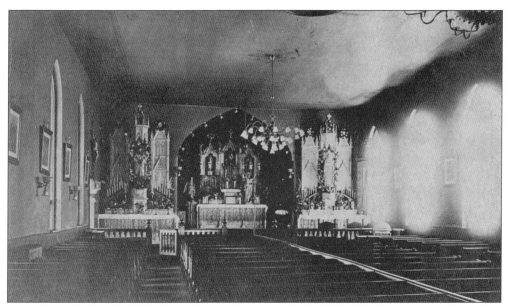

This postcard from 1912 shows the interior of the Slavish Catholic Church. It is interesting to note that this is the same church pictured above, although it was referred to as having a Hungarian affiliation. This church was located on Church Street and would eventually be replaced by Sacred Heart Catholic Church in 1923.

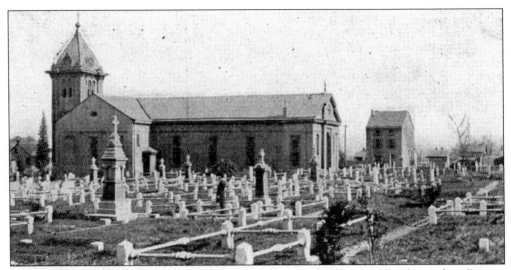

St. Mary's Catholic Church is seen in this 1911 photograph. The church is located on Dayton Street between St. Mary's and Emmett Streets. The church was traditionally an Italian parish but still exists today serving a diverse array of Catholics. Despite removal of the dome crowning the church's roof, most of the building has retained its 19th-century charm.

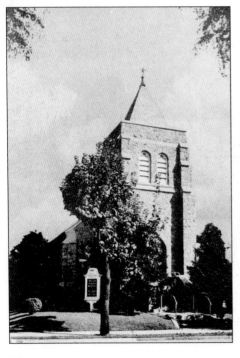

A postcard from the 1950s shows the Hungarian Reformed Church on Main Street at Third Avenue. The building looks very similar today as it did then. This was built to replace the original church located on Third Avenue at Buttonwood Street.

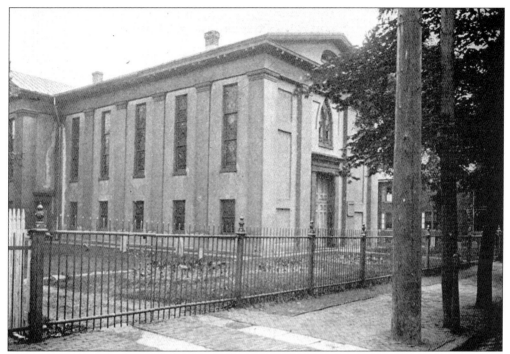

A 1907 photograph shows the Methodist church located on Church Street near Jackson Street. The Methodist church is just another example of the diverse offerings amongst the religious community in Phoenixville. The building is still there and has retained much of its original structure. It now functions as a senior center, and the Methodist church has its new home on South Main Street.

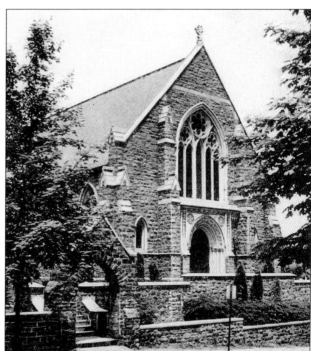

The Episcopal church is shown on Church Street near Dean Street in this 1914 photograph. St. Peter's Episcopal Church is still an active community of worship and, despite a few alterations to the property, much of it remains today as it did then.

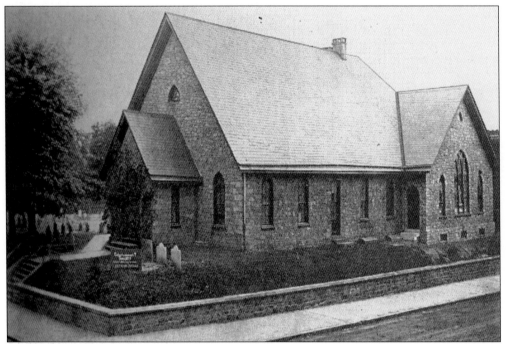

The Lutheran church was located on the southwest corner of Church and Main Streets. This was one of two Lutheran churches serving Phoenixville at the time of this photograph in 1910. The building still retains much of its original structure as seen in this image, but the tombstones visible in the churchyard are now missing.

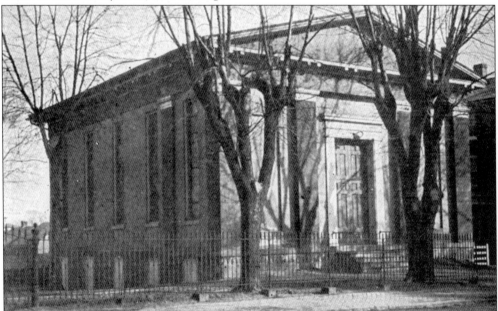

A 1911 photograph shows the Presbyterian church located on Main Street at Morgan Street. The original structure has received some modifications and a sizable addition over the years but is still recognizable from this photograph. Today, the church is still a very active member of the community, with weekly sermons and periodic events.

This 1909 postcard of St. John's Lutheran Church shows the gray stone structure that once stood along Church Street at Jackson Street. The church was located directly behind Farmer's and Mechanics National Bank, and its site is now the bank's parking lot.

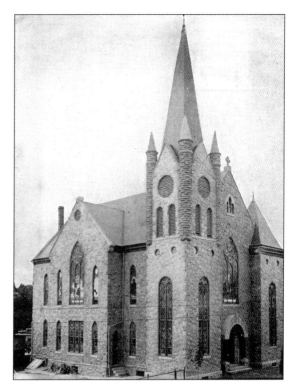

A 1962 photograph shows St. John's Lutheran Church being torn down to make way for the bank's new parking lot. By this time, St. John's had found a new home in southern Phoenixville in a neighborhood now known as St. John's Circle. The congregation continues to grow as Phoenixville's population steadily increases. (Courtesy of Larry Swartz.)

This 1924 photograph shows St. Ann's Parish School, located along Third Avenue near Buttonwood Street. This building was the original school and is still visible today despite subsequent additions made on the school grounds in 1958. It would function as St. Ann's for decades before being merged with the other Catholic elementary schools in Phoenixville and being renamed Holy Family.

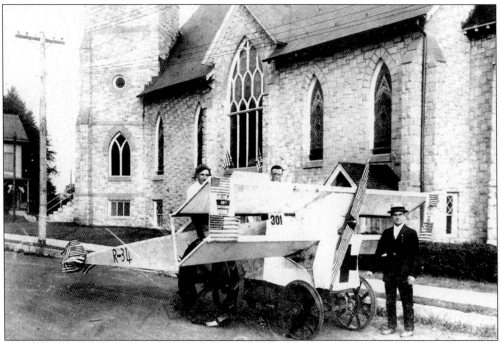

This photograph was taken in the 1930s along Third Avenue. It appears as though a small float was being readied for a parade. St. Ann's Catholic Church is visible in the background. (Courtesy of Larry Swartz.)

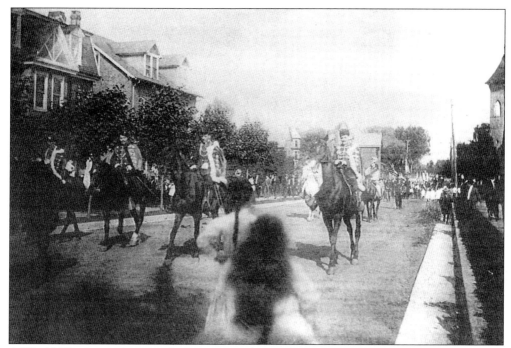

A World War I–era photograph shows a parade traveling west along Third Avenue. St. Ann's Catholic Church is visible in the background, and most of the houses at the left are still occupied and look very similar today.

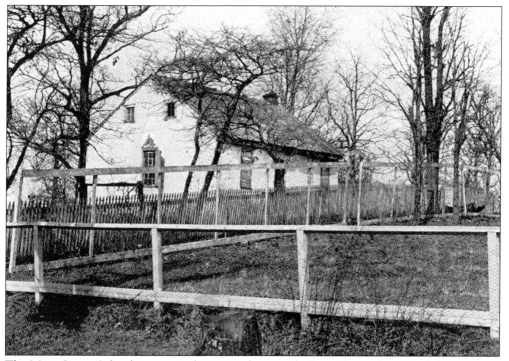

The Main Street School is seen in this 1911 photograph. It was located on South Main Street near Fifth Avenue.

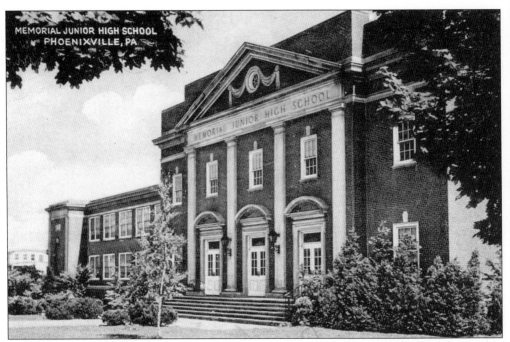

A 1938 postcard shows Memorial Junior High School, located along Second Avenue between Quick Street and Lincoln Avenue. The school was built in 1930 and served as a junior high school until 1963, when the current junior high was built on South Main Street. The school was renamed Samuel K. Barkley Elementary School and became one of many grammar schools operating in Phoenixville at the time. Despite a complete renovation in the early 1990s, the exterior of the building looks much the same today as it did in the 1930s.

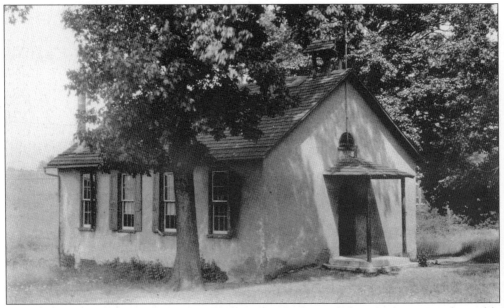

The Oak Grove School was built in 1855. This school is located along Pothouse Road, roughly across from St. Ann's Cemetery. The building's structure is largely intact, save for some renovations and an addition. It now functions as a private residence.

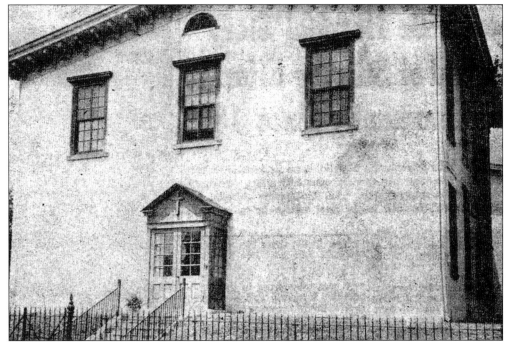

St. Mary's Parochial School is seen in this photograph from the 1920s. The school was located along Emmett Street and served children from this north side parish for many years before the new elementary school would be built. The building is still there and now functions as St. Mary's Homeless Shelter.

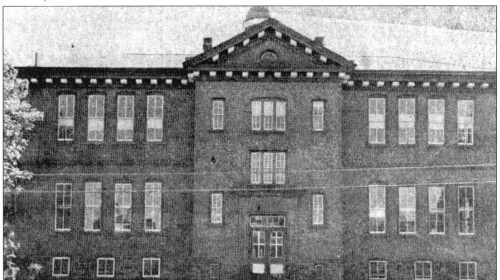

A photograph from 1943 shows Mason Street School along Nutt Road. It was built in 1875 to provide a school for children in the west end of town. It would operate as a school until 1983, when it was closed down. One interesting note about Mason Street School is that one multipurpose room functioned as the cafeteria, library, gymnasium, and auditorium. The building is still there at the corner of Nutt Road and Mason Street but has been converted to offices. The large ball field on the property was sold separately and is now the site of Pizza Hut.

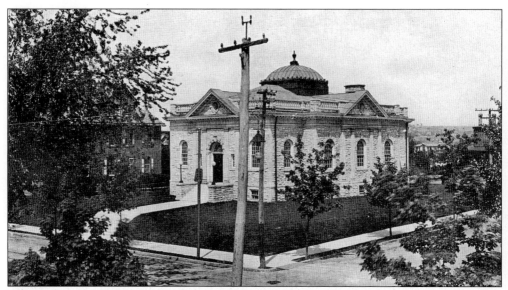

The Phoenixville Public Library is shown in this 1905 postcard. The library was made possible by a grant from Andrew Carnegie, the Pittsburgh steel tycoon responsible for funding library endowments all over America. The main library building appears much the same today as it did when it was built in 1901, except that the dome on the roof was removed long ago. A subsequent addition in 1987 has expanded the library, and it continues to serve the community from its location along Main Street at Second Avenue.

A schoolgirl is seen standing in the yard of the Gay Street School in this 1912 photograph. The Gay Street School functioned as a high school and elementary school before closing as a school in the 1980s. The building in the background has lost little of its original charm, but much of the schoolyard has been paved for parking.

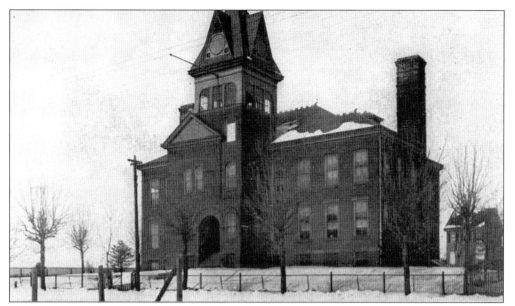

A 1908 postcard shows the High Street School, located on Phoenixville's north side. The school was located roughly in the area to Friendship Fire Department's right side and was built in the late 1800s. Today, a playground sits on the former school site.

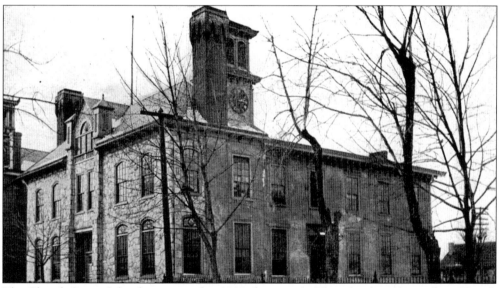

The Church Street School is seen in this 1910 photograph. The school was located on Church Street between the No. 1 Fire Company and the Methodist church. The building was later acquired by the fire company, which reworked the building into its recreation hall. The upper floors were removed, and an addition was added connecting it to the fire company building. Today, the exterior of the recreation hall still resembles the first floor of the original school building built in the 1860s.

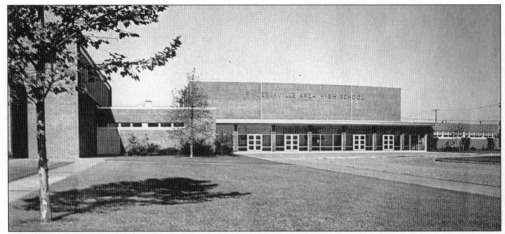

The Phoenixville Area High School is seen in this 1959 photograph. The school was built in 1956 to help meet the needs of a growing population. The school is located on Gay Street at City Line Avenue. Despite a current effort aimed at renovating and adding to the school, the original entrance shown here is still easily recognizable today.

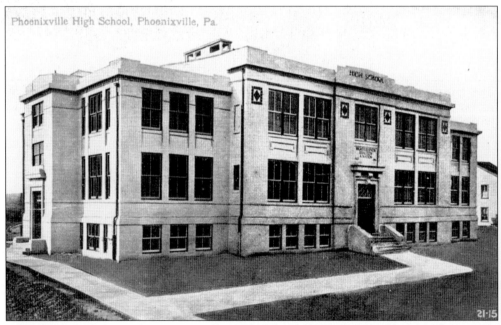

A 1914 postcard shows the Phoenixville High School, located along Nutt Road near Gay Street. Built in 1911, the high school was constructed of steel-reinforced concrete and offered separate entrances for girls and boys. It was torn down when the new Phoenixville High School was built in 1956. Today, this site is home to the Phoenixville Hospital complex.

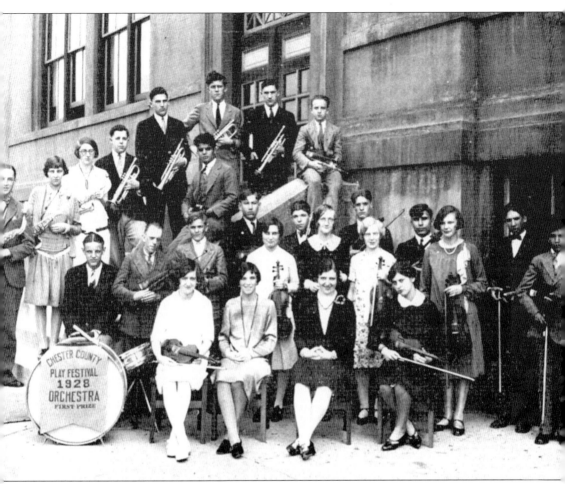

The 1928 high school band is shown in this photograph. The students are pictured around the entrance to the old high school. The banner draped over the drum indicates they had won first prize in the Chester County Play Festival that year.

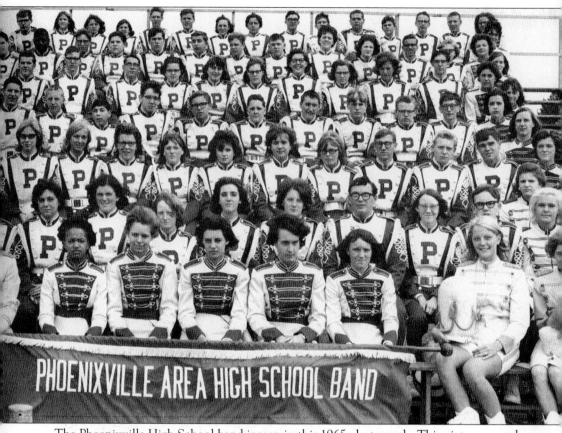

The Phoenixville High School band is seen in this 1965 photograph. This picture was taken as the band members sat on Washington Field's bleachers across Gay Street from the high school.

# Five
# TOWN AND COUNTRY

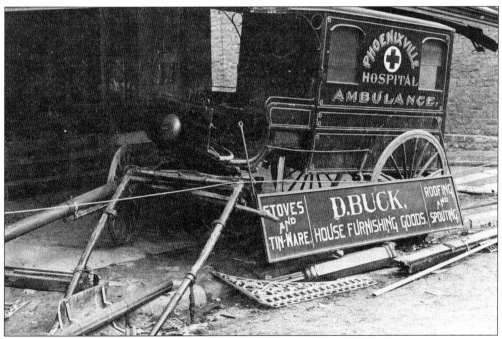

The Phoenixville Hospital ambulance is shown after having an accident along Bridge Street. The horse-drawn ambulance crashed into the porch of a business at the corner of Bridge and Bank Streets. The sign advertising "House Furnishing Goods" is shown lying amidst the rubble of the collapsed porch.

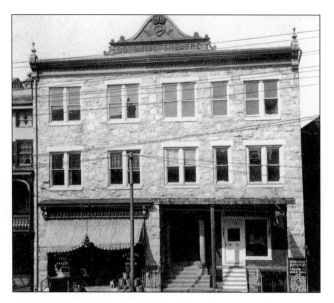

This 1904 photograph shows the original Colonial Theater building. In this image, a restaurant and store are shown, and there are steps leading up and into the theater. When the famous magician Harry Houdini performed one afternoon at the theater, it looked much like this. Years later, the facade would be radically altered, making the exterior of the theater unrecognizable from this photograph. Fortunately, the cavernous interior has been able to retain much of its original charm. (Courtesy of the Historical Society of the Phoenixville Area.)

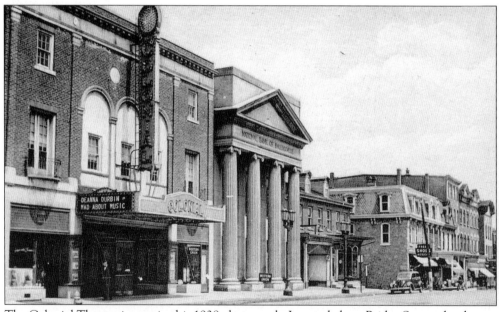

The Colonial Theater is seen in this 1938 photograph. Located along Bridge Street, the theater is easily one of the most recognizable and long-lasting businesses in town. In this photograph, the hanging sign and ticket booth are still in use. Years later, these fixtures would be removed and the facade would be altered slightly. Today, the theater is in the midst of being restored to its former grandeur and will most certainly continue to be a welcome sight in Bridge Street's commercial district.

This 1950s photograph shows the Colonial Theater and the National Bank of Phoenixville building. A bus is shown parked along Bridge Street, and the familiar hanging sign looms high above the marquis. This photograph was taken shortly before the facade of the building changed yet again with the addition of bright yellow tiles and neon lights. In 1957, the theater was used as a location in the Steve McQueen film *The Blob*. A famous scene in the movie shows patrons running in frenzy through the front entrance of the theater after realizing a creature from outer space was among them. (Courtesy of Larry Swartz.)

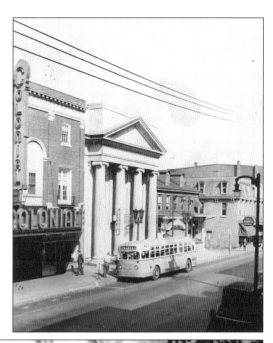

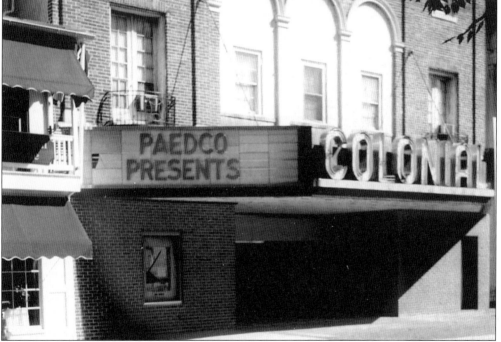

The Colonial Theater is seen in this 1998 photograph. An initiative to restore the theater had just been undertaken, and the location was seen as an integral centerpiece of Phoenixville's effort to revitalize the downtown. The interior of the theater was worn, and the exterior had lost much of its luster after so many years of use and less-than-optimal maintenance. Most of Phoenixville's residents recognize what an important economic, cultural, and historical role the theater has to play and are sure to support current initiatives aimed at making it appealing for 21st-century moviegoers.

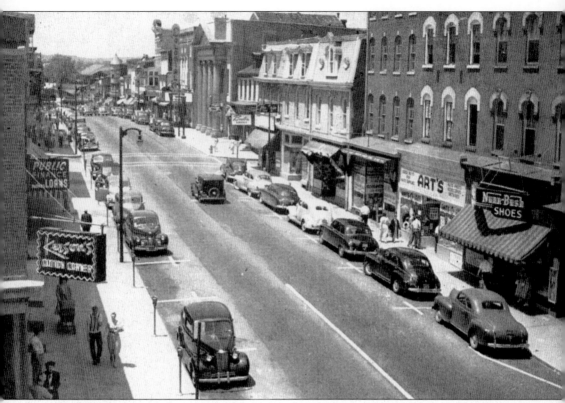

This 1940s postcard shows Bridge Street in a view looking west from Main Street. The Colonial Theater is visible in the distance, as are many other businesses. With the exception of the building advertising house paint at the far right, all of the buildings shown still line Bridge Street.

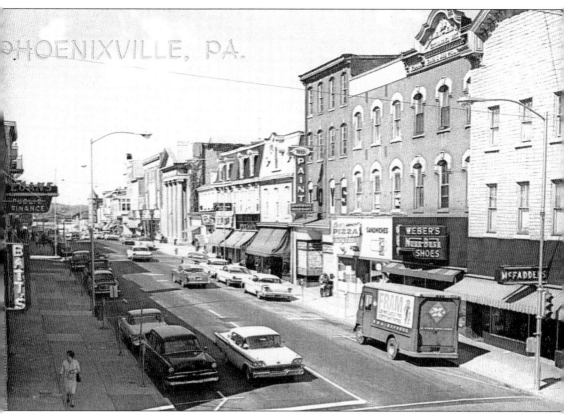

Looking west from Main Street, a postcard from the late 1950s shows Bridge Street. Although some businesses are clearly still the same as in the image on the opposite page, many have changed. The building on the corner, housing McFadden's, is the only one missing from this landscape today.

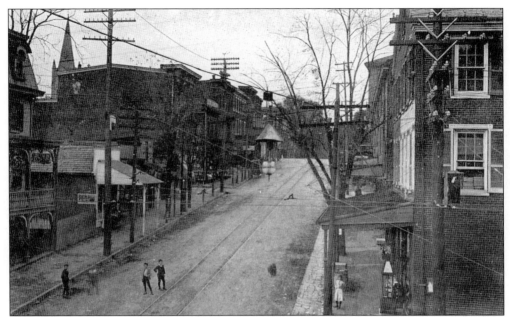

This postcard shows Main Street hill from Bridge Street in an image dating from 1908. At the left is the Phoenix Hotel. You will also notice the old lamp suspended from a wire above the street, an early precursor to present-day streetlights. The All America Shoe Store and post office are located on the left beyond the Phoenix Hotel. The steeple from St. John's Lutheran Church is visible in the background. The trolley tracks and many buildings in this image do not exist today, although the hill's slope will still be evident to anyone who has walked it.

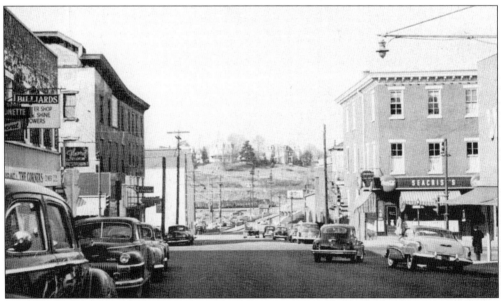

Main Street is seen in this early-1950s photograph, looking toward Bridge Street. At the right, the W.T. Grant's variety store can be seen. Some businesses visible to the left are advertising billiards and the "Corners Luncheonette." Seacrist's can be seen at the northeast corner of the intersection and is the only business from this photograph that is still operational.

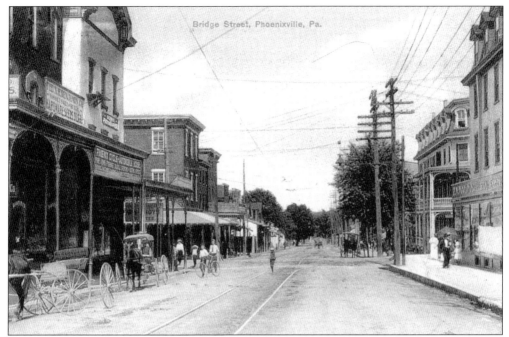

Looking east from Bank Street, this 1912 view shows Bridge Street. A sign on the building at the left advertises the "Phoenix Cycle & Automobile House." In the distance at the left is Dancy's Pharmacy, in the building now occupied by Seacrist's. At the right are the F.W. Woolworth and Phoenix Hotel buildings. This same vantage point looks remarkably different today, as only a few of the original buildings still exist.

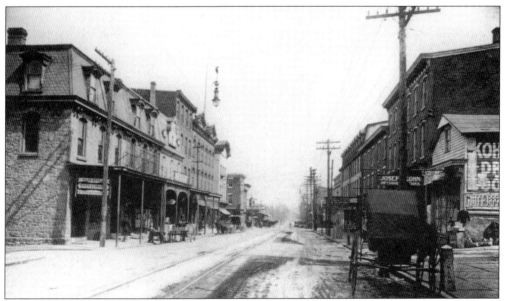

An early-20th-century photograph of Bridge Street, looking east from Bank Street, shows a variety of businesses, including Joseph Kohn Dry Goods. With the exception of the porches shown hanging over the sidewalk, many of the original buildings shown still retain the same structure. (Courtesy of the Historical Society of the Phoenixville Area.)

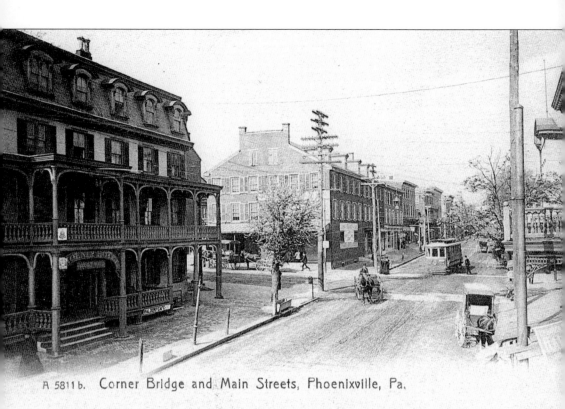

A 5811b. Corner Bridge and Main Streets, Phoenixville, Pa.

A postcard shows East Bridge Street looking west toward Main Street in 1906. The Phoenix Hotel can be seen at left, and the sign over the entrance reads "Phoenix Hotel–Jacob Wall." This picture highlights separate modes of transportation for the day, including a trolley and horse-drawn carriage. With the exception of the hotel, most of the buildings shown here exist today, albeit with many alterations.

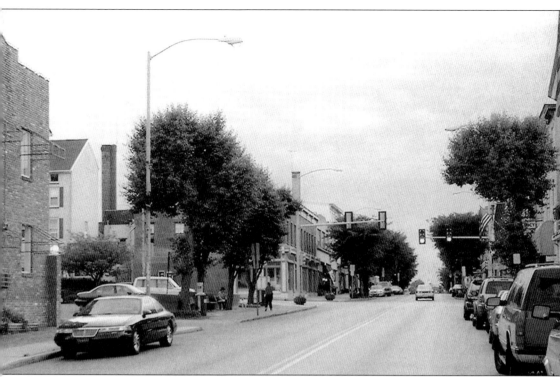

A current photograph shows East Bridge Street, looking west toward Main Street at a similar vantage point to the previous image. At the left is the Mainstay Inn and a parking lot where the Phoenix Hotel once stood. At the right, businesses line the street leading up to Seacrist's on the corner. Gone are the trolley tracks from the middle of the street, replaced by a bus stop where residents wait on benches. The horse-drawn carriages that were once such a ubiquitous presence along turn-of-the-century Bridge Street have given way to the automobile.

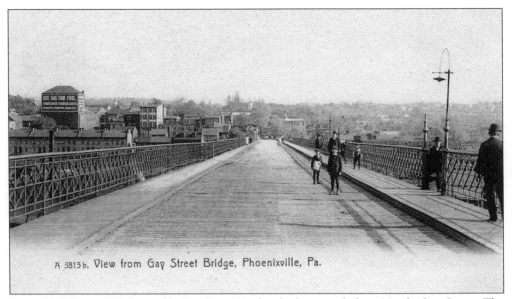

A 5813b. View from Gay Street Bridge, Phoenixville, Pa.

A postcard from 1905 shows the Gay Street Bridge, looking south from Vanderslice Street. The bridge was originally made of iron columns and had wooden planks as its surface. Homes along Mill Street are visible at the left, and the large building advertising "Use Gas For Fuel" is the Colonial Theater. This bridge would last until 1924, when the current bridge would be constructed.

The Gay Street Bridge Restaurant is shown in this 1922 photograph. Two signs near the entrance advertise Breyer's Ice Cream, and the Gay Street Bridge is at the left. Although this property would take many forms over the years, the building would be demolished in the 1990s. Currently, a grass lot is in its place on the northeast corner of Bridge and Gay Streets.

The original B'Nai Jacob Synagogue is seen in this 1945 photograph. This building was located next to the Rialto Theater on Main Street between Walnut and Hall Streets. It would serve the Jewish community of Phoenixville until the new synagogue would be constructed on Starr Street.

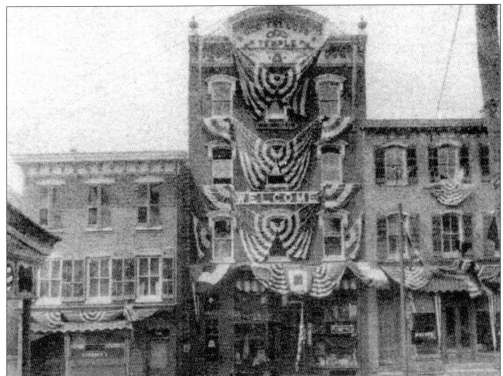

The Odd Fellows building is shown in this 1925 photograph. This fraternal organization was able to hold meetings and events on the upper floors, while the first floor was reserved for retail space. The building is still there at 237 Bridge Street, and the "Odd Fellows Temple" sign at the top remains to this day, although the group no longer occupies the space.

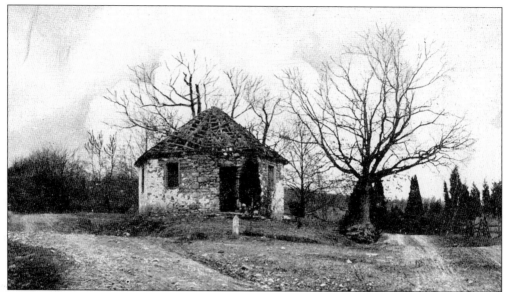

A 1908 photograph of the one-room schoolhouse on Diamond Rock Hill shows the little building in a sad state of disrepair. Located on the outskirts of Phoenixville, this small school served children of many ages from this rural locale. The school was originally built in the early 19th century and was restored in 1909. Today, the building is a treasured part of the community and is lovingly cared for by a volunteer group.

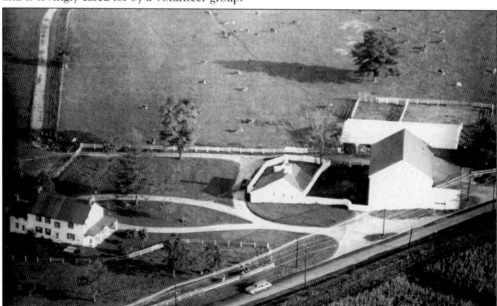

An aerial photograph from 1965 shows Patchwork Farm, located along Whitehorse Road. This is just one of many farms that lent a strong agricultural presence to Phoenixville's landscape throughout most of the 20th century. The main farmhouse is still there and continues to function as a private residence. The old barn sitting so close to the road was demolished in the 1970s. The author's family would live at and farm this land for many years, before seeing local agriculture wane and watching many of Phoenixville's farms become housing developments and shopping centers. (Courtesy of Thelma Alexander.)

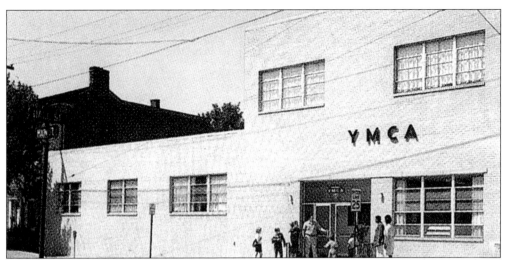

The YMCA building, on Main Street between Hall and Walnut Streets, is seen in this late-1960s photograph. The building was constructed after the Rialto Theater was torn down in the early part of the decade. The facility quickly outgrew its interior space and surroundings and was moved to its present-day location on Pothouse Road. The building was torn down, and the site is now home to a bank.

This aerial photograph shows the new YMCA property as it appeared in the 1960s. Pothouse Road runs east to west in this image, and the new YMCA building has yet to be constructed. At the left, Baker Park swim club can be seen and a sparse collection of playing fields is visible. Today, the large YMCA building and its subsequent additions can be seen to the right of the driveway entrance off Pothouse Road.

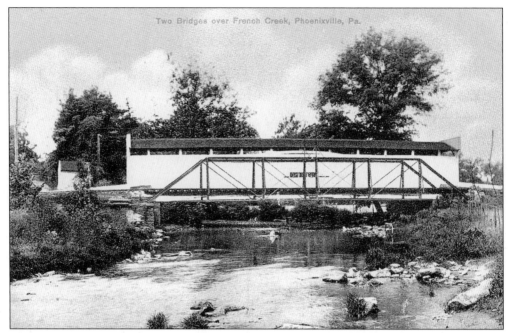

This is a 1913 postcard of the "Two Bridges over French Creek." These bridges were located on what is now Route 23 at Township Line Road. More modern concrete bridges replaced them in the 1920s.

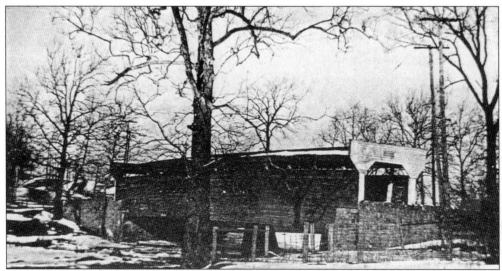

A 1927 photograph shows the covered bridge at William's Corner. This was one of a few covered bridges located in Phoenixville at the turn of the century. The bridge on Whitehorse Road straddles a creek that runs parallel to Pothouse Road. The covered bridge was torn down and replaced with a concrete bridge in 1927. (Courtesy of Larry Swartz.)

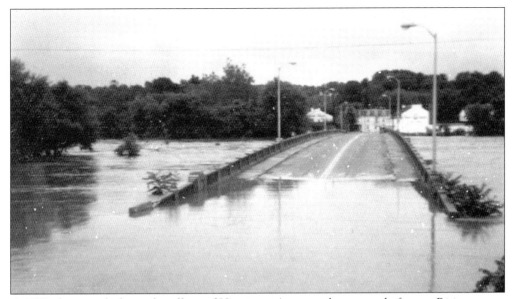

A 1972 photograph shows the effects of Hurricane Agnes at the east end of town. Rising waters of the Schuylkill River have engulfed the bridge between Mont Clare and Phoenixville. This photograph was taken in June, and much of Phoenixville and the region at large were overcome by a tide of floodwater. It was so bad at one point that residents could be seen using rowboats to travel up and down Bridge Street. (Courtesy of Thelma Alexander.)

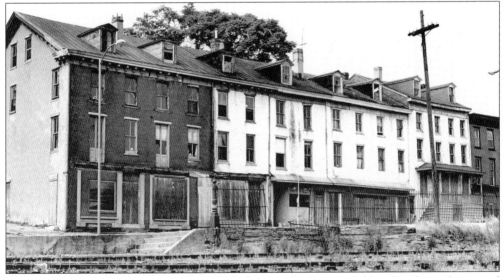

East Bridge Street can be seen in this 1985 photograph. A row of dilapidated storefronts and apartments sits vacant along this once-vibrant commercial section of Bridge Street. The row of buildings was bordered by Church Alley in the east and the Columbia Hotel's parking lot at the western end. The last building at the right was home to a cigar store and social club, called Bluejays. The derelict buildings were torn down in the late 1980s, and a grass lot remains in their place.

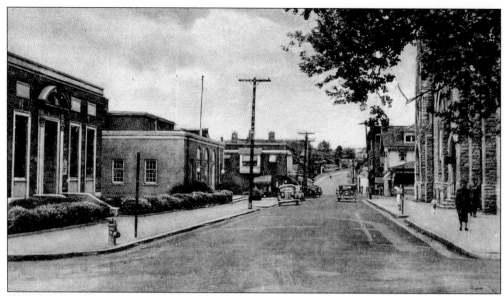

This photograph of Gay Street, looking north toward Bridge Street, was taken in 1938. One car drives solely down the street, passing the Bell Telephone building, post office, and Baptist church. The house at the corner of Gay and Church Streets has been outfitted with offices and an addition; otherwise, much of the neighborhood looks the same today.

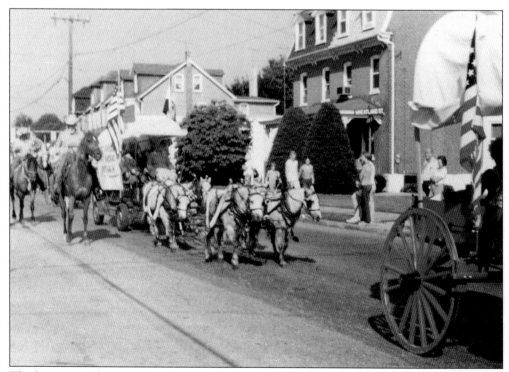

The bicentennial wagon train is seen parading down Bridge Street near Wheatland Street in July 1976. This is just one of the many bicentennial celebrations held in the borough.

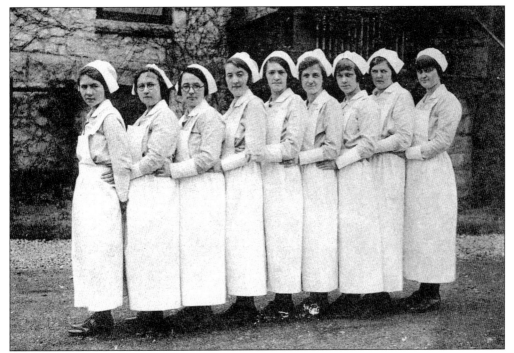
Recent nursing graduates are shown standing outside of the original Phoenixville Hospital in the 1920s.

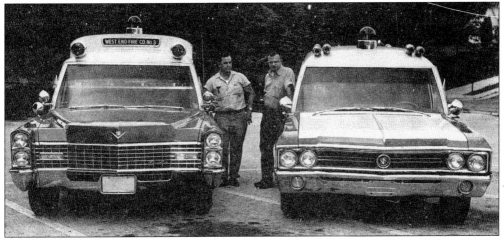
A 1960s photograph shows an ambulance for West End Fire Company. The ambulance at the left is a Cadillac, while the other is a Buick. Considered quite modern for the time, they appear to be no more than station wagons in contrast to the modern ambulances we know today.

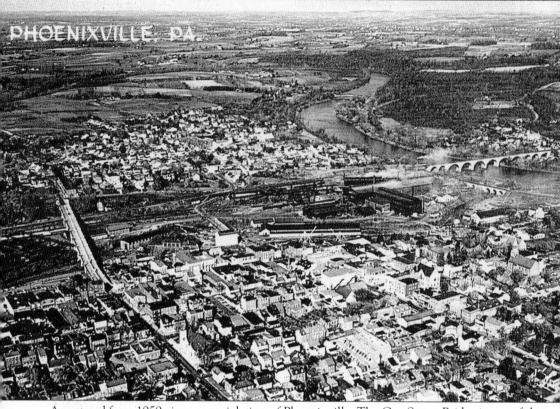

A postcard from 1959 gives an aerial view of Phoenixville. The Gay Street Bridge is one of the most prominent landmarks. A careful examination will reveal that many of the structures shown are still there today.

# Six
# THE SPORTING LIFE

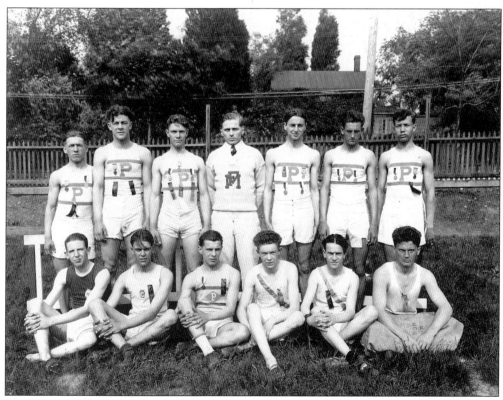

The Phoenixville High School track team is seen here in this early-20th-century photograph.

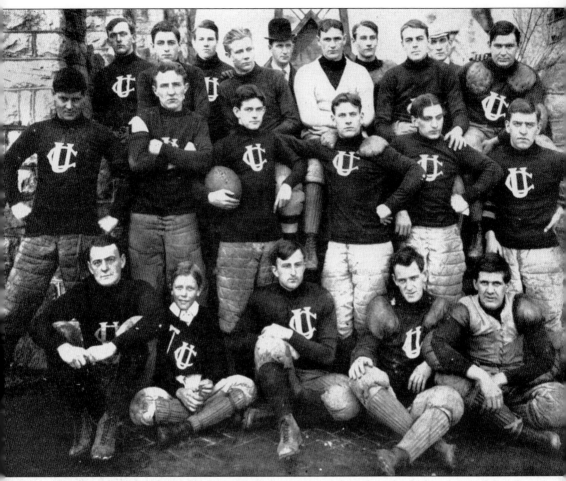

Members of the Union Club football team are gathered around the steps of St. Peter's Episcopal Church in 1908, a short walk from their playing field. (Keinard Collection, courtesy of Glenn C. Cagle.)

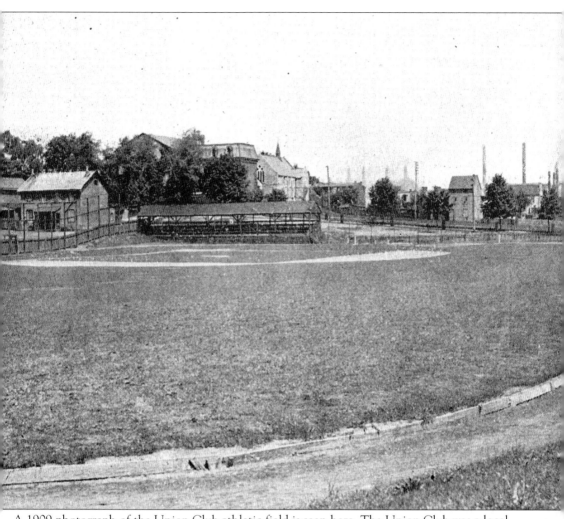

A 1909 photograph of the Union Club athletic field is seen here. The Union Club was a local sports club established in 1907. This field was located along Starr Street and bordered by Prospect Street at the north end. The house visible in the background is located on Prospect Street, and St. Peter's Episcopal Church is partially visible at the left.

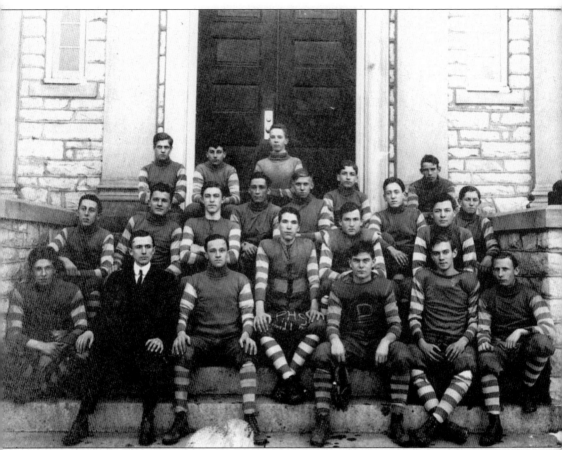
The 1911 Phoenixville High School football team is shown on the steps of the public library.

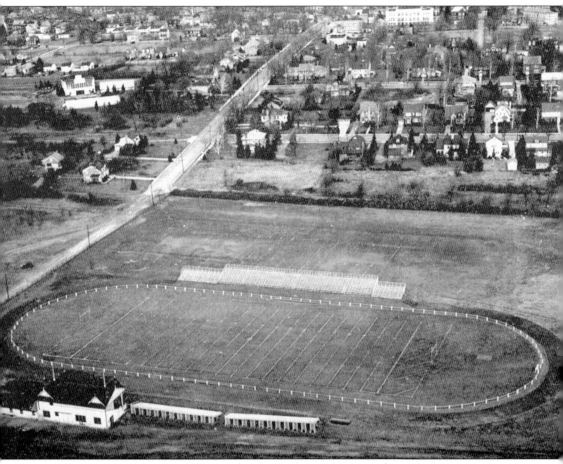

An aerial view of Washington field in the 1920s shows the area along City Line Avenue bordered by Main Street in the east and Gay Street in the west. Many of the homes shown are still there today, although the barn at the left is but a memory of the distant past.

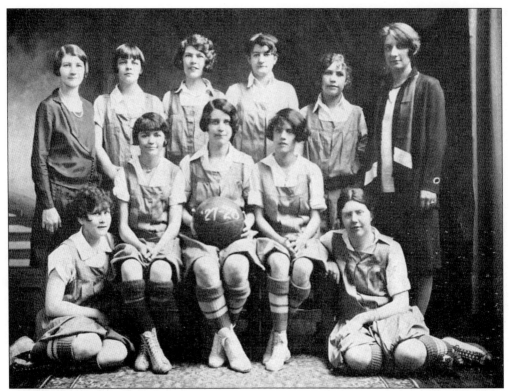
The 1927 Phoenixville High School girls' basketball team was an early girls' sport team organized in Phoenixville.

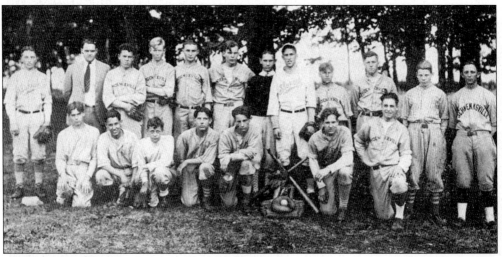
Phoenixville High School's baseball team is seen here in 1928.

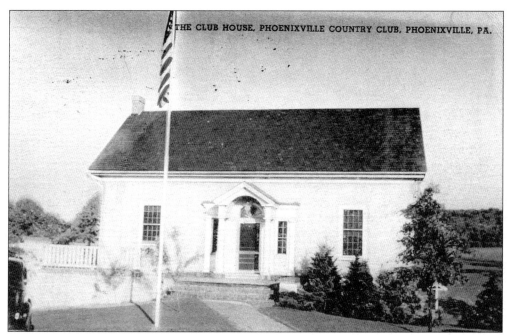

The clubhouse of the Phoenixville Country Club is seen in this 1938 postcard. The country club sits at the intersection of Country Club and Valley Park Roads. The club boasts a nine-hole golf course and banquet facilities, which have played host to a number of local social events over the years. This building is still on the grounds and looks much the same today.

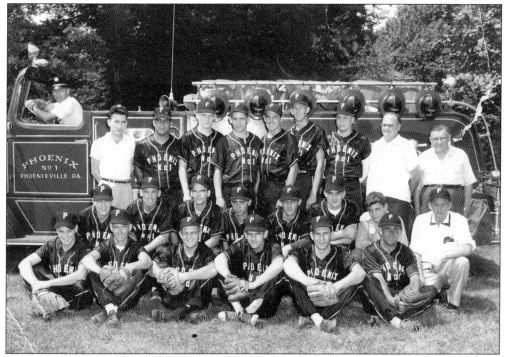

This 1956 photograph shows the No. 1 Fire Company softball team. The players are grouped together in front of a 1940s fire truck. (Courtesy of Toggy Sierzega.)

# ACKNOWLEDGMENTS

During the process of composing a book, it becomes evident that it is not only the author contributing to the work, but an eclectic list of sources through which the final composition is wrought. It becomes necessary at that moment to express gratitude for those who helped make the book a reality and to acknowledge their generosity and assistance.

First and foremost, I wish to extend my sincerest thanks to my parents, Jean Martino and Vincent Martino Sr., for instilling in me a genuine interest in Phoenixville's history and development, and also for giving me the education and personal foundation integral to making such an accomplishment possible. I also wish to give thanks to the multitude of friends and associates who contributed images, information, and time in an effort to bring about this history of our town. Last, but certainly not least, I am beholden to Christine, whose love, support, and inspiration I could not live without.

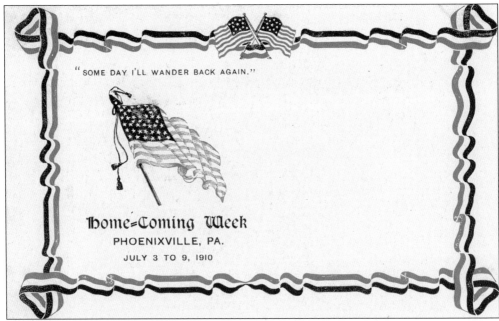

A postcard from 1910 is informing its recipient of homecoming week in Phoenixville. The card has a patriotic theme and features the dates of the celebration. There is also a line from a song that says, "Some day I'll wander back again." These words represent a timeless gesture beckoning all Phoenixville residents, past and present, and letting them know that one can always call Phoenixville home.